IMAGES
of America

THE BLACK HILLS PASSION PLAY

IMAGES
of America

THE BLACK HILLS
PASSION PLAY

Johanna Meier

ARCADIA
PUBLISHING

Published by Arcadia Publishing
Charleston SC, Chicago IL, Portsmouth NH, San Francisco CA

Printed in the United States of America

Library of Congress Catalog Card Number: 2007943010

For all general information contact Arcadia Publishing at:
Telephone 843-853-2070
Fax 843-853-0044
E-mail sales@arcadiapublishing.com
For customer service and orders:
Toll-Free 1-888-313-2665

Visit us on the Internet at www.arcadiapublishing.com

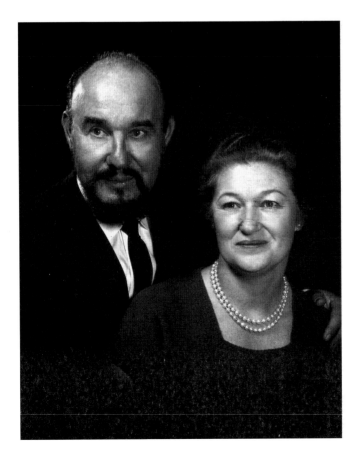

I lovingly dedicate this book to my parents, Clare and Josef Meier, whose inspiration provided this history.

CONTENTS

ACKNOWLEDGMENTS

Many people have contributed their memories and historical materials in the compilation of this retrospective. To all those friends and supporters of the Black Hills Passion Play, I offer gratitude and appreciation. The citizens, churches, and businesses of Spearfish have upheld their commitment in seeing the play through nearly 70 years of production and handling the millions of visitors who have come to their community.

My family has always been supportive in this undertaking; my husband, Guido Della Vecchia, and cousins Shirley and Henry Meier have contributed their knowledge and good advice in assisting me with this endeavor. The Black Hills Passion Play staff and actors have also contributed their support in assembling many of the materials; executive secretary Geraldine Butterfield and company manager Charles Haas have both been instrumental in facilitating my efforts.

Most of the early photographs of the Black Hills Passion Play are credited to Joseph Fassbender, his son, George Fassbender, and the Black Hills Studio in Spearfish. For many years the official photographers of the production, the Fassbenders' pictures have appeared in all the programs and much of the advertising through the years. All uncredited archival images appear courtesy of the caretakers of their estate, and to whom I am most grateful for allowing the use of the photographs in this history.

Thanks also go to the Black Hills Pioneer, Simpson's Printers, the Spearfish Chamber of Commerce, and particularly to Roberta Sago, archival librarian at Black Hills State University, who assisted in the scanning and assembling process.

And finally, to the audiences of over 10 million people, four generations of families, and individuals who have attended the Black Hills Passion Play and made it a theatrical legend, thank you and God bless.

INTRODUCTION

Writing a history of the Black Hills Passion Play is a monumental task, given the amount of archival material to sort through and cataloging the memories of a number of people. Everyone has his favorite story to tell, whether of early Spearfish history, the touring years, actors' experiences, and even animal participation. The Black Hills Passion Play is also the story of lives: of my parents, Josef and Clare Meier, my own recollections, and those of the people who helped build and run this enormous undertaking. It was a combination of spiritual dedication, theatrical expertise, rugged physical activity, enormously detailed preparation, and physical and mental stamina.

The history of the play cannot be separated from its founder, and all this was wrapped up in the amazing persona of my father, Josef Meier, a true renaissance man, and the commitment he inspired in others over the course of 60 years. His energy was incredible, his drive boundless, and his capacity for detail unique. He was a man of vision, whether for himself, his production, or his community. That does not mean that he was a man without faults; he was an astute businessman, had an enormous ego, and was very committed to his opinions both of people and situations. He continually sought excellence and would not rest until he had achieved the best possible results from his cast, his employees, and even from his animals. This high standard was ingrained in me from the time I was a child, and he expected behavior and achievements to follow the family pattern that he had established.

The Black Hills Passion Play grew in national recognition and prospered, and the times lent themselves to this development. After World War II, people were eager to travel again, and tourism took on new importance as the Black Hills became a popular family destination, rapidly taking over as the second-largest industry, after agriculture, in the state of South Dakota. The road tours continued as well, bringing the play to larger audiences nationwide and encouraging them to visit it in its natural outdoor setting. This history will take us through the early years and bring us up to the present time and generation.

In the United States, there are several passion plays in existence, most are church funded and produced and have met with varying success. None has been accorded the recognition that the Black Hills Passion Play has achieved through its long history of production, its nationwide tours, and its spectacular outdoor setting. The best known of the European passion plays still extant is performed every 10 years in Oberammergau, Germany. Passion plays originated as teaching tools for Christianity, and they have basically remained such, with the addition of modern theater techniques and visual enhancements. They hold a unique position in the development of classical theater and remain vital and perhaps even more necessary in our rapidly changing secular world. The story that the Black Hills Passion Play re-creates is a timeless one, and the production is as relevant now as it was in 1932, when it first reached American shores.

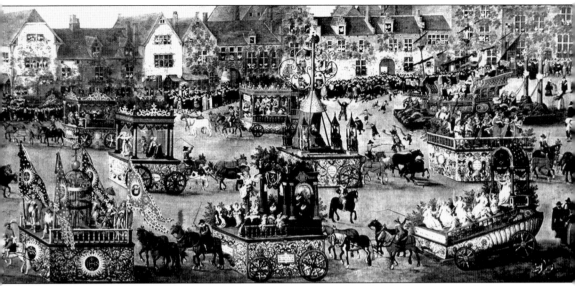

In medieval France and England, trade guilds re-created individual scenes, and there was great rivalry over who could produce the most lavish setting. In England, wooden sets were constructed on wagons that could be pulled around the open areas to be viewed by the crowds, and in southern Europe, old Roman theaters were used, and some stage machinery was created to depict effects such as the fires of hell. These plays were called "Mystery" plays (after the Latin word *ministerium*, or service). As they entered the vernacular, they became less formal, often representing players like the devil and Herod as comic characters. (In recent times, the English National Theatre presented a trilogy of these plays entitled *The Nativity*, *The Passion*, and *Doomsday*, sometimes all in one day, or alternating night after night.) As the form developed, the presentations also became known as "Morality" plays—depicting good and bad qualities and their effect on ordinary men. Townspeople began to take important roles, which were often then passed down through generations. A portion of *Isabella's Triumph*, above, depicts a parade of wagons displaying scenes from the Bible. (Victoria and Albert Museum, London.)

One

BEGINNINGS

Passion plays are among the earliest forms of theatrical presentation and appeared throughout Europe in the Middle Ages. Originally performed within churches and cathedrals, they were used as a means of teaching the populace, which could neither read nor write. The clergy represented all the characters. As the crowds increased, more elaborate versions of the scenes had to be moved outside onto the church steps or in the large squares facing them. Ultimately the clergy were forbidden to participate in these outdoor performances. This stained-glass window, a 12th-century glass panel at Chartres Cathedral in France, depicts Jesus as teacher, as he would have appeared in early church tableaux.

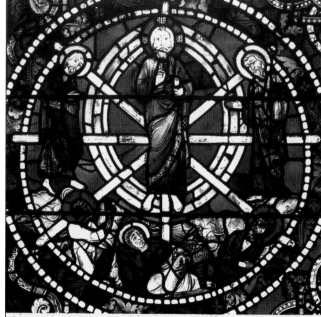

"And after six days Jesus took with him Peter and James and John his brother, and led them up a high mountain apart. And he was transfigured before them, and his face shone like the sun, and his garments became white as light. And behold, there appeared to them Moses and Elijah, talking with him." Matthew 17:1–3. Twelfth-century stained glass panel at Chartres Cathedral, France.

9

Early theater nearly always utilized spectacle, physical combat, and violence or obscenity as an intrinsic element in their public appeal; actors were not considered reputable. With the rise of Christianity, the church established strict rules forbidding participation in theatrical diversions. The emergence of the passion plays created a bridge, planting theatrical roots in religious soil. Like Greek theater, Shakespeare, and Italian Commedia del'Arte, the early passion plays hold an important place in the history of the theater.

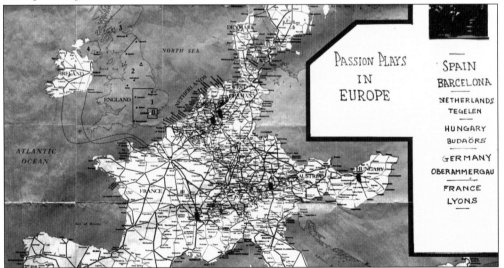

A handful of passion plays are still performed in Europe—in Hungary, Spain, France, and the Netherlands. The best known is produced in Oberammergau, Germany, every 10 years. After the village was spared during one of the central European plagues of the Middle Ages, the populace vowed to present a passion play every decade. The entire town is involved in its presentation. The play runs throughout the course of a day, including many tableaux and choral preludes. In recent years, the play has been revised for political correctness and boasts more avant-garde design in costumes and scenery. This map indicates the remaining European passion plays still in existence.

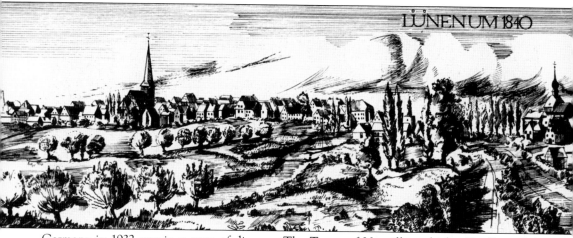

Germany in 1932 was in a state of disarray. The Treaty of Versailles, which officially ended World War I, left European politics in flux. Germany had lost Alsace and Lorraine, and German colonies were placed under the League of Nations mandate. Adolf Hitler had begun his ascent to power. The churches, too, were under pressure. A curbing of religious traditions came to a dramatic head in 1930 when religious plays were banned for the first time in German history. Pictured is an early drawing of Luenen, Westfalen, Josef Meier's birthplace.

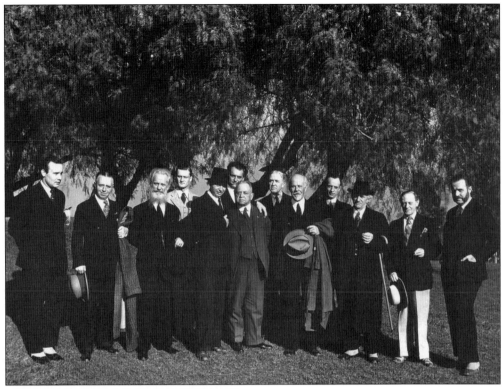

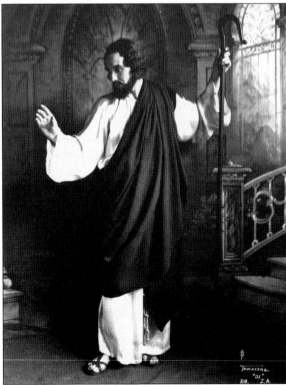

In Westfalen, Josef Meier, one of a family of nine children, had begun the study of medicine at the University of Munster. The representation of a biblical play in Luenen reportedly traced its roots back to 1242, when traditional Easter tableaux had been mounted by monks at a monastery near his home. As the gradual development toward a more structured presentation took place, laymen and community members took over the parts formerly played by the clergy. When the fate of the centuries-old tradition seemed to be in jeopardy, it was decided to send a small group to tour America in hopes of keeping the play alive. The young Meier, then 24, was designated as the director and Christus portrayer. The company of actors is pictured above with Meier on the left. The portrait at left shows Meier as the young Christus, around 1933. (Black Hills Passion Play archives.)

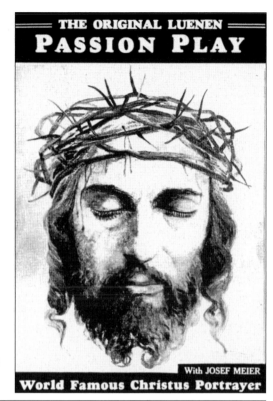

THE ORIGINAL LUENEN
PASSION PLAY

With JOSEF MEIER
World Famous Christus Portrayer

The troupe arrived in New York with an assortment of biblical costumes, a tattered text, and about $1,000 among them. Their destinations were the German-speaking communities that had sprung up in major urban areas, fostering small German theaters and German-language church congregations. The play was presented on a shoestring, with the somewhat makeshift scenery often being put in storage and the actors finding temporary jobs until the next booking could be arranged. Seen here are two images of early advertising.

TICKETS
For
LUENEN
PASSION
PLAY
ON SALE HERE

MODEL PRINT

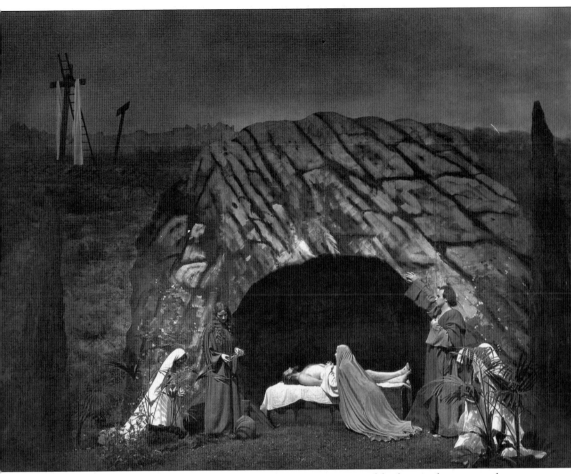

As conditions in Europe worsened, many of the German cast felt the need to return home to face with their families whatever lay in the future for their homeland. Josef Meier, given the inevitable alternative, decided that the future for himself and the play lay in America, and he set about translating the play into English, shortening it to accommodate modern theater audiences and hiring American actors to replace those who were returning to Germany. The picture is of the burial in the tomb. (Black Hills Passion Play archives.)

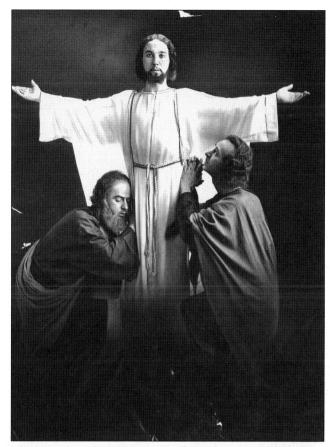

Originally the play contained other scenes from the Bible, as did most of the traditional passion plays. Although the title "passion play" indicates the passion, or suffering, death, and resurrection in the final week of Jesus's life, a nativity scene had been included in this early version, as well as several tableaux of Christ's ministry and the miracles that he performed. These were deleted, bringing the play into a more reasonable format of two and a half hours, including an intermission. Shown are two pictures from the original production, "Come unto me, ye that are heavy laden" (at right) and Mary Magdalene anointing the feet of Jesus. (Black Hills Passion Play archives.)

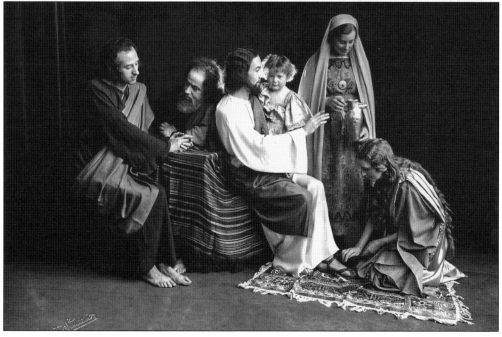

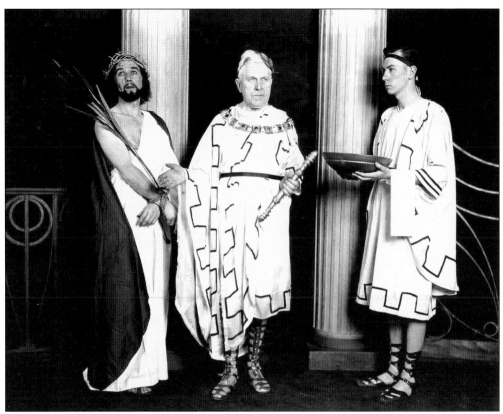

This picture shows Josef Meier as the Christus and Paul Dietz, from the original cast, as Pontius Pilate. (Black Hills Passion Play archives.)

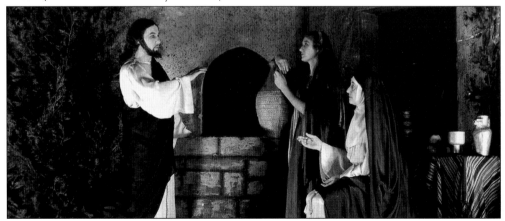

Among the new American cast members to be hired was Clare Hume, a young actress from Chicago. Having come from a theatrical family herself, she was unfazed by being asked to join a touring company, leaving the next day! Her long, beautiful hair served the production well as she assumed the role of Mary Magdalene; it also caught the eye of director Meier, and in 1936, they were married. Soon after, Clare Hume Meier began playing the role of Mary the Mother, which she continued until her retirement some 50 years later. Shown in the Bethany scene are Josef Meier as the Christus, Clare Hume Meier as Mary Magdalene, and Mary Rose Brown as Mary the Mother. (Black Hills Passion Play archives.)

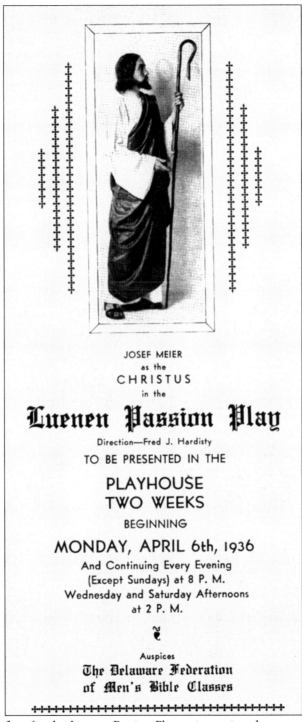

JOSEF MEIER
as the
CHRISTUS
in the

Luenen Passion Play

Direction—Fred J. Hardisty

TO BE PRESENTED IN THE

PLAYHOUSE
TWO WEEKS

BEGINNING

MONDAY, APRIL 6th, 1936

And Continuing Every Evening
(Except Sundays) at 8 P. M.
Wednesday and Saturday Afternoons
at 2 P. M.

Auspices
The Delaware Federation
of Men's Bible Classes

This is a publicity flyer for the Luenen Passion Play as it continued to tour, now playing larger engagements, since the English translation, made in 1935, provided greater theatrical opportunities for the company. Josef Meier was now firmly established as the leading Christus portrayer in the theater of the time, and his name became synonymous with passion play production.

ONCE IN A LIFETIME
You Have the Opportunity of Seeing

The Great European
PASSION PLAY

Only
Authentic
Company
En Tour

This Is
Not A
Motion
Picture

ORIGINAL CAST IN ENGLISH

Players From Original European Organization Meistersingers, One Hundred Voices

300 Cast Chorus Ensemble Orchestra

Gorgeous Pageantry —o— **Thrilling Drama**

Auspices of Meistersingers, San Bernardino

To Be Presented Before Thousands on A Huge 250 Foot Stage

Roosevelt Bowl, Perris Hill Park, San Bernardino, California

MON. & TUES., SEPT. 9—10, 1935, 8:00 P. M.

Admission—Adults 50c, 75c, $1.00 and $1.50, plus Tax. Children 25c.

Passion Play Headquarters, Citizens National Bank, E and 3rd Street Phone 312-07

Ticket Office Open Daily 9:00 A. M. to 5:00 P. M.—Secure Tickets Now

The company had taken its first big step in the transition from an unknown European entity to a world-renowned theatrical production. The next step would be establishing a permanent home for the production in America.

Two

THE BLACK HILLS PASSION PLAY OF AMERICA

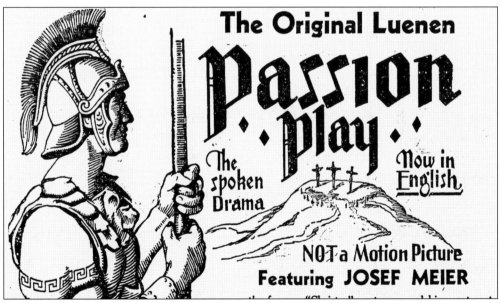

By 1936, the Luenen Passion Play began to find a foothold in the United States. Engagements were booked, taking the play from its early venues in churches and neighborhood theaters to larger urban audiences. The tours began to encompass more of the country, and Josef Meier was searching for a permanent location. He spoke of his dream in interviews and public appearances, and offers began to come in: the Blue Ridge Mountains, the Ozarks, and even Riverside, Redlands, and Malibu in California. Negotiations had commenced in the Shepherd of the Hills country of Missouri when a cross-country tour brought the company to Sioux Falls, South Dakota, the only city of any size at that time in the state.

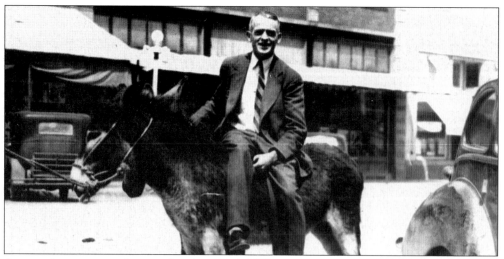

A committee representing nearly every Black Hills community contacted Josef Meier, urging him to take a few days to visit this natural beauty spot in the far western part of the state. In 1937, there was a two-lane highway crossing the prairie, parts of which were still gravel. Sculptor Gutzon Borglum was hard at work, carving the famous faces of Mount Rushmore into a granite mountainside, but aside from rodeos and rock shops, there was little to draw tourists to the area. The committee was chaired by Spearfish businessman Guy Bell. Bell sits on one of the play's donkeys on Main Street.

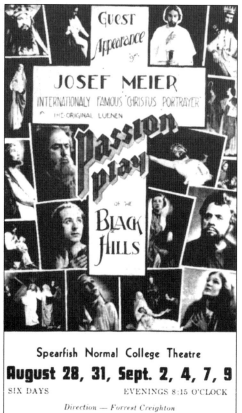

Meier was offered the Stratosphere Bowl in Rapid City, where the world's first stratospheric balloon was launched, but Rapid City was unable to assemble financial support for the project. It looked as though the play was headed for Missouri, but Bell was persistent, and Meier agreed to return from San Francisco to review sites in Spearfish. This is the original program from the Luenen Passion Play's first performances in Spearfish, at the Black Hills Normal College. These performances marked a beginning for many local families who would be associated with the play as extras, a tradition which has carried into a fourth generation.

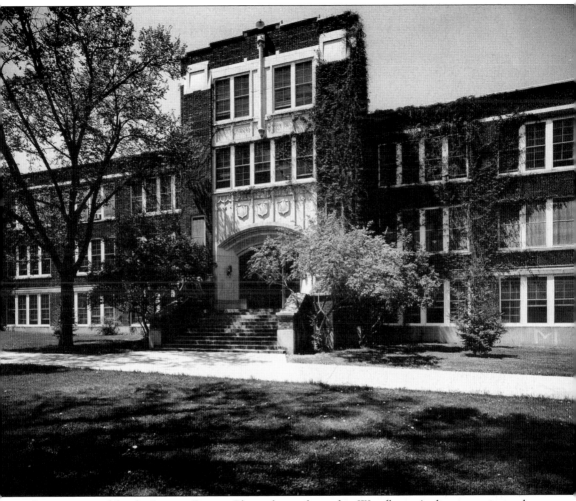

It was arranged for the Luenen Passion Play to be performed in Woodburn Auditorium, pictured, at Black Hills Normal College (now Black Hills State University), so that the community could see the production that they were being asked to support. The audience for opening night was 150, but subsequent showings brought so many more that the play was held over and more performances were added. It quickly became apparent that the community was prepared to back the undertaking.

Meanwhile, after considering four locations in the Spearfish area, the committee brought Josef Meier to Bertha Newton's cow pasture, a hillside at the edge of town. The backdrop of Lookout Mountain was spectacular, and it happened that there were people in the apple orchard down below. Their conversation could be clearly heard, which added the promise of good acoustics to the package. The pasture was acquired, and work on the stage and seating began during the winter of 1938–1939. The photographs show construction underway during the winter of 1938. (Black Hills Passion Play archives.)

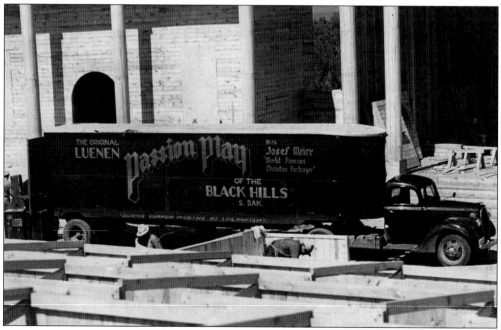

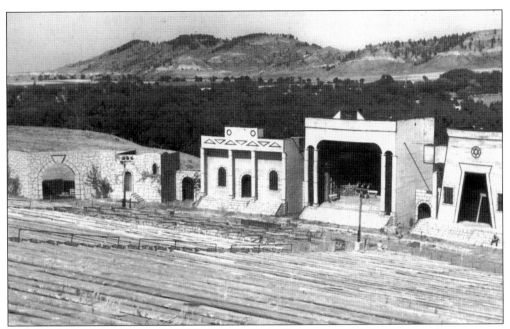

Seats were primitive; they consisted of wooden planks on posts. The permanent stage set was designed by Josef Meier and has remained essentially the same through the years.

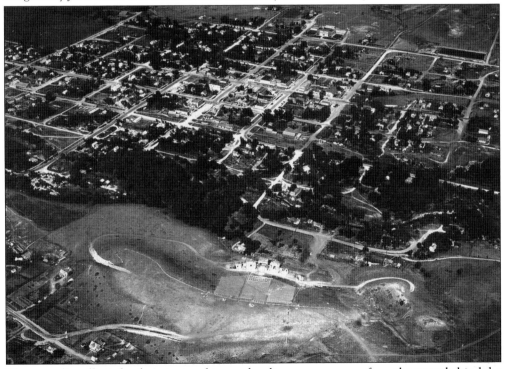

There was literally no landscaping; parking and audience access came from the street behind the theater. This aerial photograph shows the newly constructed amphitheater in its relationship to the small town of Spearfish, 1939. Note that no major highway is visible. The two-lane Highway 14 ran through the middle of town as Main Street.

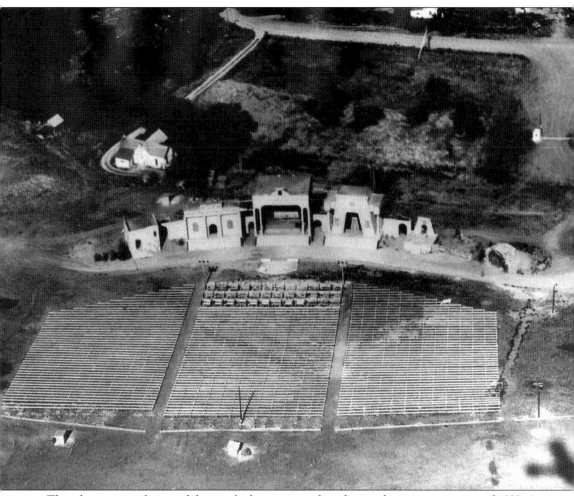

This close-up aerial view of the amphitheater was taken during the opening season of 1939. As there was no proper box office, tickets were sold on Main Street in the office of the commercial club, forerunner of the chamber of commerce. Note Bertha Newton's house at the upper left. The audience entered via the existing roadway, and the small building at the upper right served as a box office. Then they would proceed up the path on the right and come into the amphitheater from behind the set. Note also two small outhouses at the top of the seating area for audience convenience and the shadow of the plane that took the photograph at the lower right.

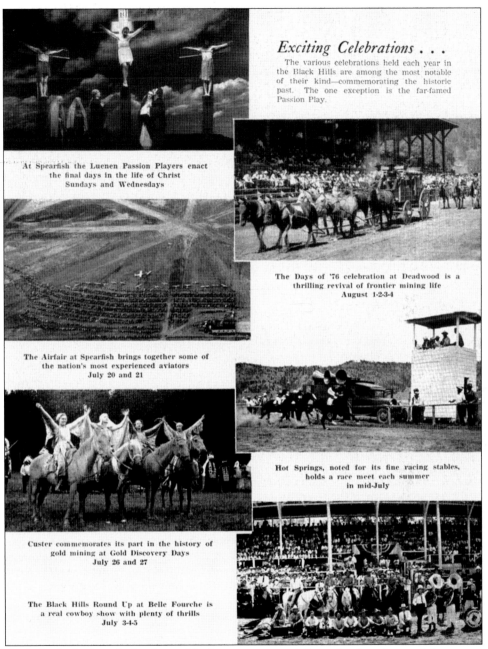

Exciting Celebrations . . .

The various celebrations held each year in the Black Hills are among the most notable of their kind—commemorating the historic past. The one exception is the far-famed Passion Play.

At Spearfish the Luenen Passion Players enact the final days in the life of Christ Sundays and Wednesdays

The Days of '76 celebration at Deadwood is a thrilling revival of frontier mining life August 1-2-3-4

The Airfair at Spearfish brings together some of the nation's most experienced aviators July 20 and 21

Hot Springs, noted for its fine racing stables, holds a race meet each summer in mid-July

Custer commemorates its part in the history of gold mining at Gold Discovery Days July 26 and 27

The Black Hills Round Up at Belle Fourche is a real cowboy show with plenty of thrills July 3-4-5

Asked why he had made this leap of faith into an essentially undeveloped part of the country, Josef Meier stressed the tremendous potential of the area, with its stunning natural beauty of the Black Hills and the Badlands, all within easy driving distance for travelers to visit during a few days while on their vacations. It was also apparent to members of his family that the location resonated with his boyhood dreams of the American West. The wide-open spaces, cattle ranches, horseback riding, hunting, and the lure of the unknown drew many European settlers toward the West throughout the formative years of the country. The image is from a 1940 visitors' guide, showing the Passion Play as the only summer attraction aside from several rodeos, a horse race, and an air fair.

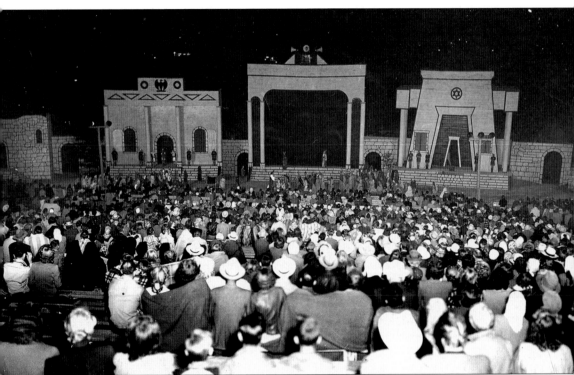

Opening night of the newly renamed Black Hills Passion Play of America was Sunday, June 18, 1939; it was cold and rainy, and the audience numbered 1,132. The local paper *Queen City Mail* reported, "Regardless of the cold which forced some to leave before the three hour production ended, only praise was heard for the work of the actors. Many remarked on the beautiful voice tones of Josef Meier, Christus portrayer . . . the Crucifixion Scene, with its marvelous lighting and sound effects, held the crowd in awe. The scene of the Last Supper created a feeling of reverence among the spectators that held throughout the production." Pictured is one of the early audiences during an actual performance in the summer of 1939. The first summer the Black Hills Passion Play drew 14,852 visitors, but by 1940, audiences had dwindled. Most of the local public had seen the play, and attendance fell to under 6,000. The committee was in financial trouble and asked Josef Meier to take over ownership and responsibility for the entire undertaking. (Black Hills Passion Play archives.)

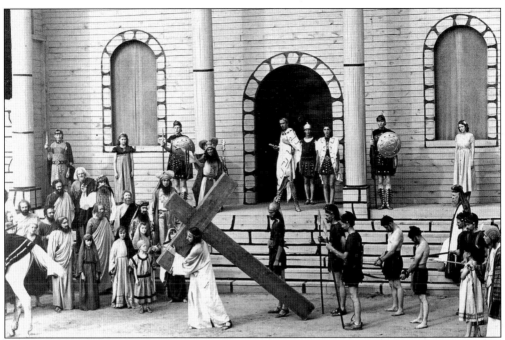

The original agreement had called for the committee to cover construction costs, backing, all advertising, and extras needed for crowd scenes and for Meier to direct and furnish production, actors, costumes, animals, and props. To meet the new challenge, Meier approached the First National Bank in Spearfish and requested a 10-year loan to meet the committee's debts. By fall the Passion Play was on the road again, and the profits came directly back to Spearfish to pay off the loan. The tour also served a promotional purpose—in each new city, the publicity urged audiences to "see the Passion Play in its spectacular outdoor setting." Pictured are two views of Meier, in costume as the Christus carrying his cross during a performance and standing on the porch of the same building (Pilate's palace) contemplating the future of his great gamble. (Black Hills Passion Play archives.)

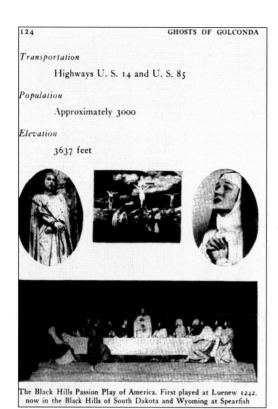

Transportation

 Highways U. S. 14 and U. S. 85

Population

 Approximately 3000

Elevation

 3637 feet

The Black Hills Passion Play of America. First played at Luenew 1242. now in the Black Hills of South Dakota and Wyoming at Spearfish

This image is taken from a Black Hills guide and history book, *Ghosts of Golconda* by S. Goodale Price. Note the current population of Spearfish. (Western Publishers.)

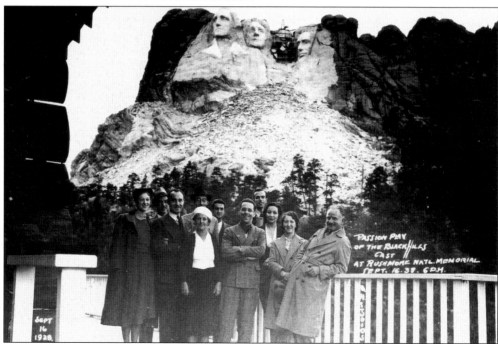

This is a picture of the Black Hills Passion Play actors visiting Mount Rushmore during the spring of 1939. Still being created is the head of Theodore Roosevelt, the last of the U.S. presidents to be depicted on the mountain.

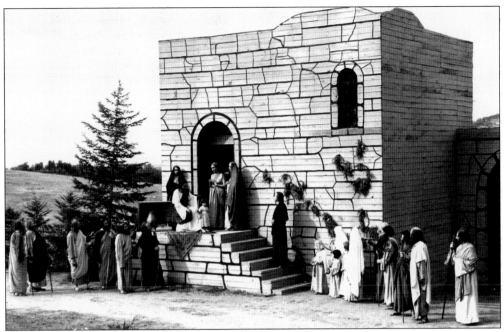

The amphitheater was still not landscaped, and the actors recalled going out in the woods to cut trees before the performance, which were propped up around the buildings to "dress the set." Pictured is the Bethany scene; note the absence of formal landscaping surrounding the stage. Josef Meier is pictured as the Christus; the author is the Child. (Black Hills Passion Play archives.)

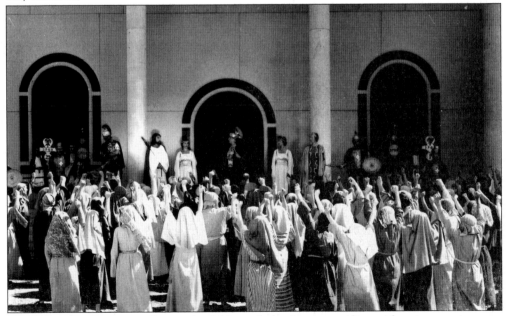

Local people were eager Supers (extras), each business providing either its owner or an employee to participate in performances. Families began coming backstage, and the first generation of Spearfish children grew up with the Passion Play as an important part of their summer activities.

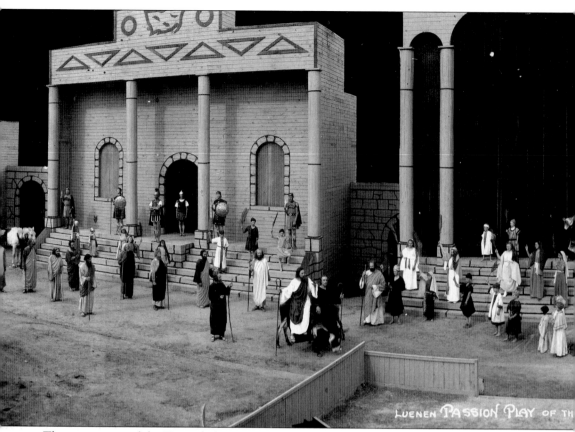

This is a picture of the Triumphal Entry scene at the beginning of the Black Hills Passion Play. Based on what is now celebrated as Palm Sunday, it depicts Jesus's arrival in Jerusalem, riding a donkey, followed by his disciples, and being welcomed by throngs of people. The Roman Guards

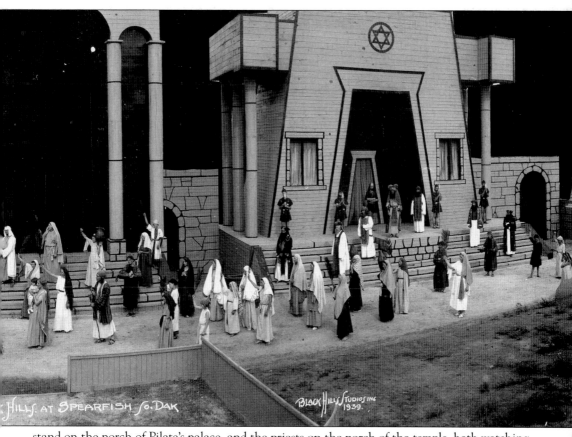

stand on the porch of Pilate's palace, and the priests on the porch of the temple, both watching the joyous arrival, unaware of the drama that would unfold during the following days. (Black Hills Passion Play archives.)

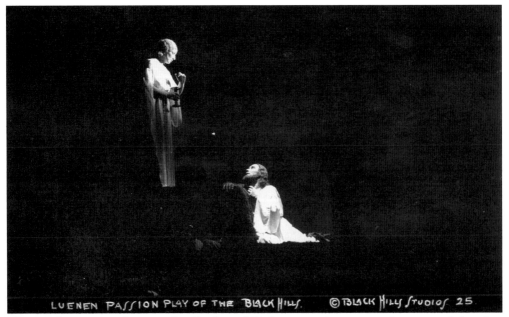

The angel appears to Jesus in the Garden of Gethsemane during a performance of the play. She holds the Holy Grail, which Jesus shared with his disciples during the Last Supper, and her appearance follows his line, "Cannot this cup pass away, except I drink it?"

Attendance the next summer was up to 17,000, and Josef Meier began upgrading the facility, building a ticket office and improved seating, dressing rooms for the Supers (theater parlance for supernumeraries, or extras, often referred to as Supers), and stables for the horses. Note the still primitive facilities for visitors coming to a performance; the parking, restroom, and box office entrance are all very congested. (Black Hills Passion Play archives.)

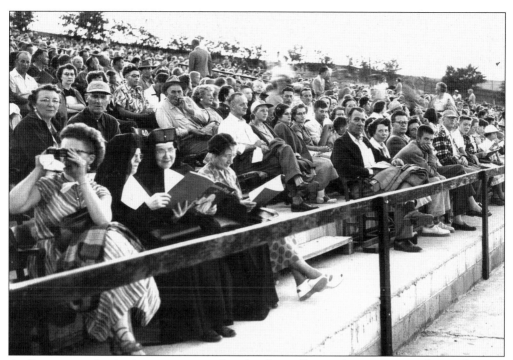

Audiences were beginning to come to the play from all over the country, as the yearly tours urged people to travel to the Black Hills to see the production in its new outdoor setting. (Black Hills Passion Play archives.)

This is a picture of the lighted stage set during a performance. The scene is the March to Golgotha, as the mounted Roman Guards, the Temple Guards, the two Thieves, the Christus carrying his cross, and the crowd prepare to cross the bridge and climb the hill to Golgotha, where the Crucifixion scene will take place.

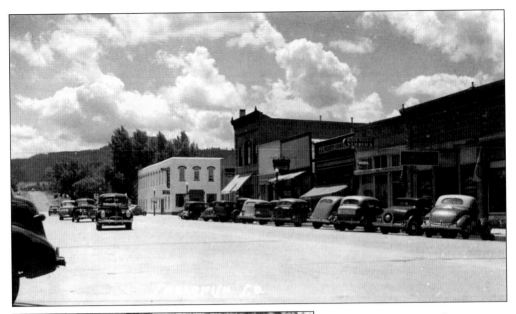

© Bernie Butcher 2006

The community, too, began to develop. Initially very limited amenities were provided for visitors—a couple of cafés, a small hotel, and several primitive cabin camps. Early Spearfish Main Street is seen above. An additional part of the original contract called for the paving of Spearfish Canyon road, until then undeveloped for tourists. Today it has been designated a national scenic byway and is considered one of the premier beauty spots in the Black Hills.

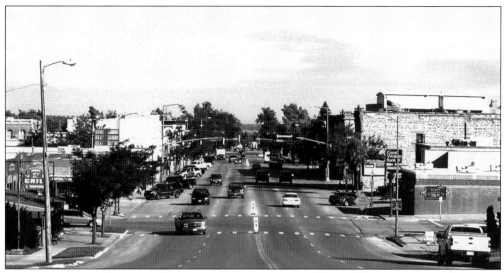

Several small motels were built, and a restaurant appeared. It would be some years before the first stoplight was installed, but Spearfish was on the move. Pictured here is a more recent shot of Main Street.

The surrounding towns in the Black Hills also began to benefit from the presence of the Black Hills Passion Play. This advertisement is reprinted from the *Rapid City Journal,* Thursday, June 15, 1939.

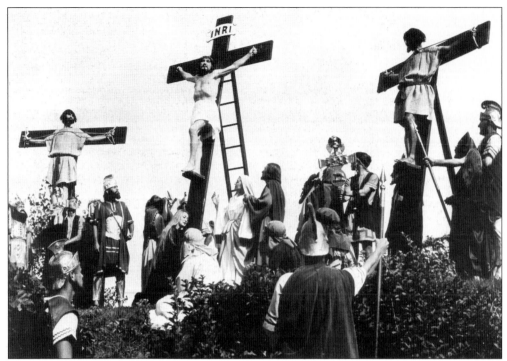

This is a picture of the Crucifixion scene on the Mount of Golgotha, originally played on top of the hill, reached by a winding path.

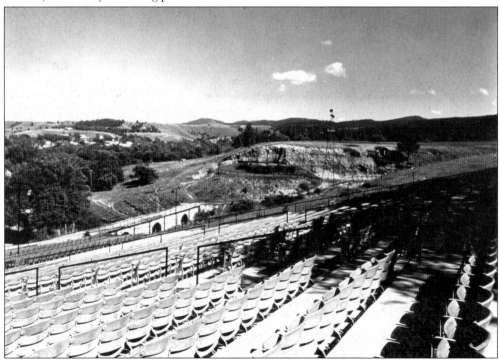

This photograph was taken shortly after the hillside was modified by being cut out, improving the sound and lighting effects for Golgotha. (Black Hills Passion Play archives.)

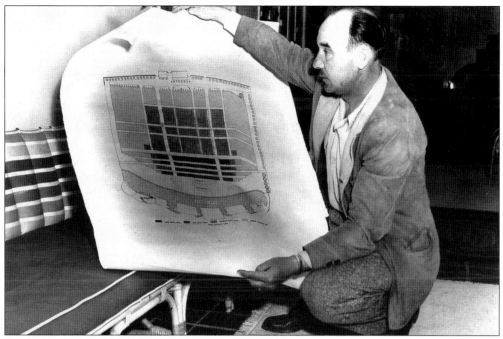

As the years passed and the initial promise was fulfilled, the Spearfish Amphitheatre facilities were continually improved. Here Josef Meier contemplates the plans for the installation of stadium-type seating, or seats with backs.

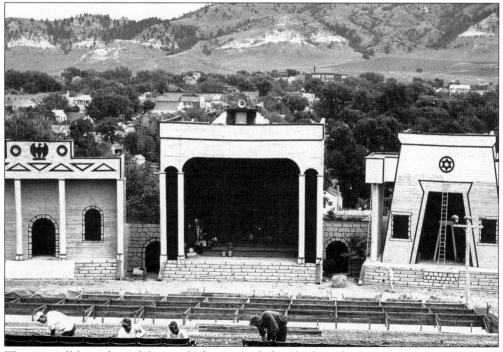

This is a still later shot of the amphitheater, including both stadium seating and original pine planks. Handrails and landscaping were added, probably in the late 1940s. (Black Hills Passion Play archives.)

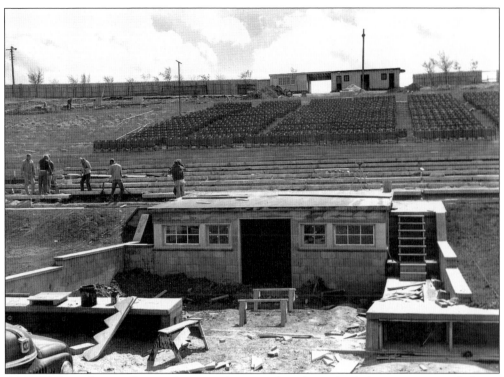

Also added was the installation of an organ house and pit, from which the intricate stage lighting could be controlled.

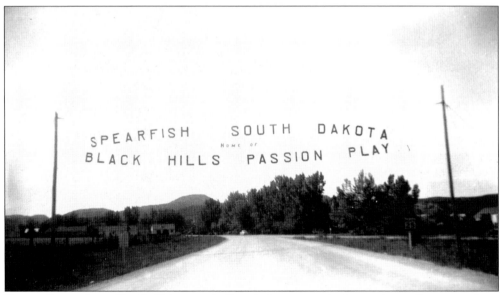

Eventually new box office facilities were built to help manage the increasing audience numbers. The parking lot was also extended, and a car count was taken (by state) during each performance. Often more than 20 states were represented. Spearfish had now become the official home of the Black Hills Passion Play of America, proudly proclaimed by banners that were displayed at both east and west entrances to the town.

Three

THE TOURING YEARS

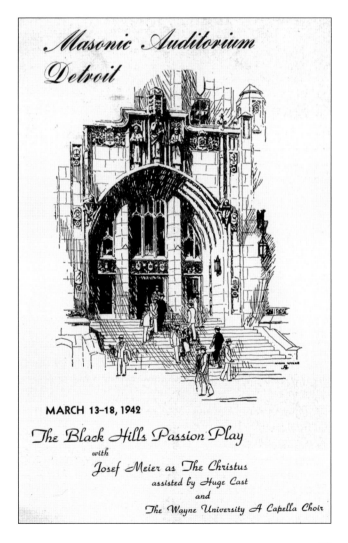

Circumstances had changed a great deal from the early, tentative touring days of the Passion Play. Originally the troupe toured by train, which had become a risky business, as the Passion Play cars often had to wait on a siding to be picked up by another train. By the 1940s, the company was transported by a fleet of cars and two semitrucks. Traveling by car gave the production much greater range, and the cross-country odysseys became legendary. Shown is a program from Detroit 1942.

Masonic Auditorium Detroit

MARCH 13–18, 1942

The Black Hills Passion Play

with

Josef Meier as The Christus

assisted by Huge Cast

and

The Wayne University A Capella Choir

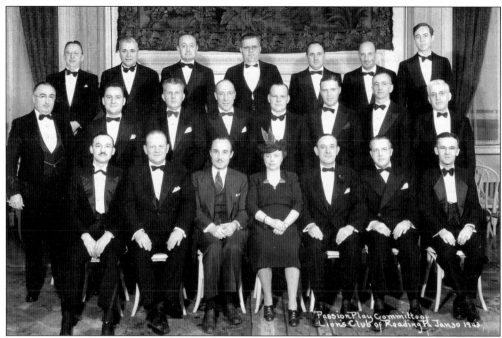

Tours were booked at least six months in advance, and engagements varied from occasional one-night stands to several weeks, depending on the size of the city and the interest shown. The proceeds were divided with a sponsor, usually a civic organization like the Kiwanis or Lions Club, junior chamber of commerce, or a university. Pictured is the Lions Club committee from Reading, Pennsylvania, in 1943, with Josef Meier, center. (Black Hills Passion Play archives.)

We dedicate these performances of the Passion Play to the Missionaries who in these trying hours have remained with their people to minister to their souls and their bodies. May He who suffered and died, and rose again to save all men, give them courage and strength to carry on.

We dedicate them also to our service men, near and far, that they, faithful to the Counsels of the Master, may have His protection and bring to our glorious Country, Victory and Peace.....

To those who humbly and patiently worked with us in this endeavor, we express our deepest appreciation.

The Catholic Mission Aid Society
(The Society of the Propagation of the Faith)

Sponsors

NOTICE

The Bushnell Memorial is thoroughly organized and equipped for your protection in the event of an air raid. In such an emergency this auditorium is a far safer place than the streets, which are to be kept clear by the air wardens.

If a warning comes you will be notified from the stage, and the performance will then continue. Please cooperate with us by staying quietly in your seat and remaining calm, thus setting a good example to your neighbor.

Occasionally a church organization such as the Knights of Columbus used the engagement as a fund-raiser. However, the Black Hills Passion Play has never been a church-sponsored production, in contrast to most other American passion plays. With an interdenominational cast, it has always been privately owned, directed, and operated by the Meier family, and all arrangements for its production were made directly with Meier. The inside of this program indicates that this engagement is to be used for a specific purpose by the sponsoring organization.

Tours generally commenced in the early fall, running from September through mid-December. After a break for the Christmas holidays, the company reassembled and traveled from January until the end of April. One of the actors, seen here with Meier, filled in during the Christmas break by playing Santa Claus at a Chicago department store.

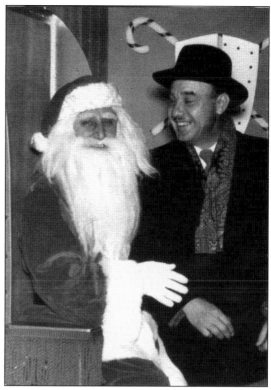

In addition to the cast of professional actors, the Passion Play carried its own stage crew, lighting technician, and organist. Pictured are Clare and Josef Meier coming in the stage door, greeted by the head electrician, Tim Shanahan.

1950

ENGAGEMENTS

JANUARY
14.-19.

Fort Smith,Ark. (Popul.:60000
Jan.14. - 19.
Jr.H.Sch.Auditorium
Cap.:1500
Sponsor: LIONS CLUB
(Corr.: Mr.E.B.Sparks
)2211 - North B.Street
(% Lions Club Sec'y
)Fort Smith,Ark.

5000/3000

February see next page.

MARCH
5.-12.

Dallas,Tex.
March 5. - 12.
"Fair Park Auditorium"
Sponsor: LIONS CLUB
(Corr.: Dallas Lions
) Club
(Room 2011, Adolphus
) Hotel
(Dallas,Texas

10000/10000

APRIL
2.-10.

FORT WORTH,Texas
April 2. - 10.
"Will Rogers Audit."
Cap.: 2290
Sponsor: LIONS CLUB
(Corr.: Lions Club
) Office
(Texas Hotel
) Fort Worth,Texas

10000/10000

February
16.-21.

Beaumont, Texas
Febr. 16. -21.
" City Auditorium"
Sponser; Lions Club
Conn.; Harry F. Walton
Perlstein Bldg.
Beaumont, Texas

6000/6000

March
28. -31.

Waco, Texas
March 28. -31.
" Waco Hall"

FEBRUARY
2/24. -
3/2.

San Antonio,Texas
Febr.24. - March 2.
"Municipal Auditorium"
Sponsor: KIWANIS CLUB
(Corr.: Kiwanis Club
(Room 312, Gunter Hotel
(San Antonio,Texas

5000/5000

11-12-13-17, Lake Charces La.

3000. 2400 1000.- 5950

Mich 2-4829

There were usually three "advance men"—promoters or press agents who had experience in dealing with touring productions. During the summer, they gathered in Spearfish to map out the year's itinerary, creating a feasible touring route. As the touring season approached, the first advance man traveled to the opening city, formalizing contracts and agreements with the sponsors. The theater was decided upon, usually a municipal auditorium or university theater, then performances were scheduled, tickets and programs were printed, Super participation was lined up, a substantial choir was hired, and housing for the cast and livestock was arranged. This is a typical page from Josef Meier's touring date book in 1950.

BLACK HILLS PASSION PLAY
JOSEF MEIER
STAGE MANAGER'S REPORT

City...
Auditorium..
Procenium Opening (Height)....................
Procenium Opening (Width)....................
Inside Height...
Wall to Wall..
Curtain Line to Back................................
Sets of Lines..
Number of Pipes.......................................
Switchboard Connection...........................
DRESSING ROOMS:
 Stage Floor ..
 Above ...
 Below ...
 Supers ..
Supplies Requested.................Pipes.............ft.
 Pipes.............ft.
CAR AND TRUCK STORAGE:
 Name ..
 Address ..
 Rate ...
Housing Livestock....................................
Feed Supply Firm......................................
 Address ..
 Phone ...
 By:

After the initial arrangements were made, the first advance man left for the next city, and the second advance man arrived. It was his job to follow up on the preliminary schedules, to see that they were implemented. A printed form was completed to submit to Meier, the stage manager's report. This image is a copy of a stage manager's report, which had to be submitted preceding the company's arrival.

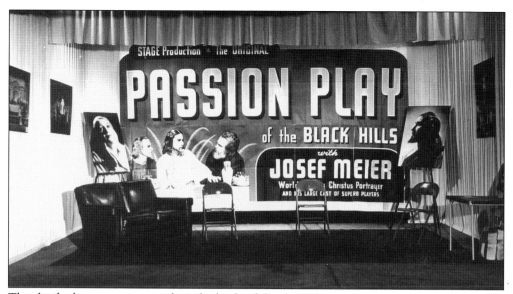

The third advance man arrived on the heels of the departing second man and stayed with the company for the duration of the engagement. He handled all the daily problems, arranged radio and newspaper interviews and pictures, introduced Meier to town dignitaries and officials, and kept tabs on the box office sales and personnel. He had to be a combination of publicity agent, mediator, slave driver, and facilitator, with a strong dash of old-fashioned showman thrown in. Pictured are two typical promotional displays, one perhaps prepared for a press conference, the other the window of a downtown business, cities unknown.

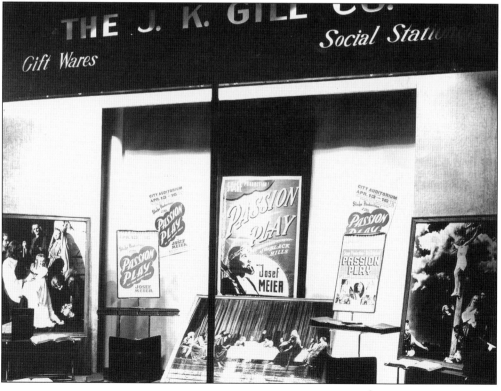

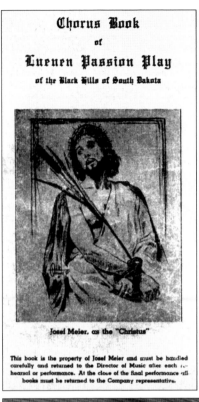

Chorus Book
of
Luenen Passion Play
of the Black Hills of South Dakota

Josef Meier, as the "Christus"

This book is the property of Josef Meier and must be handled carefully and returned to the Director of Music after each rehearsal or performance. At the close of the final performance all books must be returned to the Company representative.

Black Hills Passion Play trucks carried two complete sets of rigging (used alternately depending on the size of the stage and proscenium), a cyclorama and backdrops, numerous curtains, a lighting board and spotlights, overhead borders, and mounted lights to stand in the wings, miles of cable, two collapsible stage platforms and two sets of stairs, scenery, 35 trunks of wardrobe and props, private company and office trunks, a Hammond organ, and 50 choral scores, as well as feed and bedding for the livestock. Shown is the front cover of one of the musical scores for the chorus.

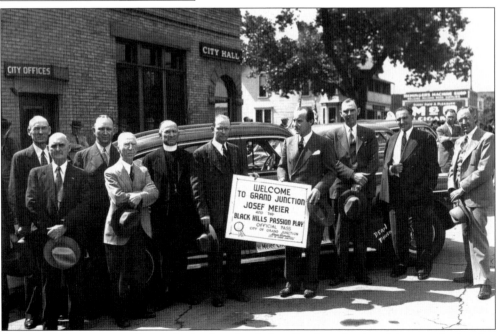

It was a grueling pace, and actors had to be a hardy lot. On the other hand, it was a fascinating life, with many interesting places to visit, acquaintances to be made, and challenges to be met. Christmas cards from state and city officials and former committee members poured in for years. The Grand Junction welcoming committee stands with Josef Meier, holding the sign.

The author's earliest recollections were of long car trips, outings with her governess to local libraries and museums, and, of course, the performances themselves. Johanna Meier made her stage debut at the age of five weeks and traveled with the company until she was eight years old. By the time she started school in Spearfish, she was already well advanced in reading and writing. Johanna is pictured with her governess, Abby Fausch, and her pet dachshund.

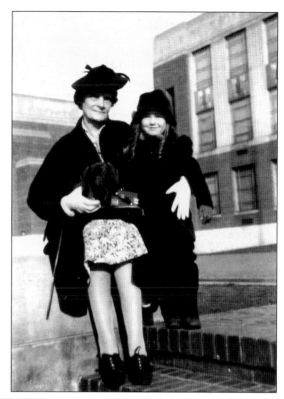

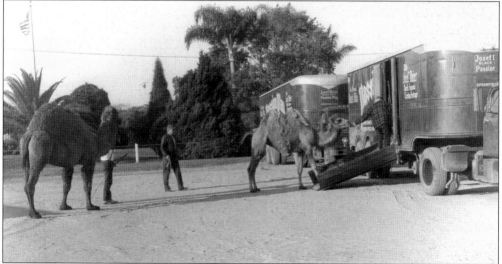

Actors traveled in four limousines. Josef Meier drove his own car, with Clare Meier, Johanna, and her governess (later the company secretary). The route was mapped in advance. The "jumps" between engagements could be long or short. Often the company packed up after the final performance and drove all night to reach its next destination. The troupe travelled during blizzards, wind, and rain and suffered flat tires and occasional accidents. During one trip, the livestock truck overturned, killing one of the camels. No engagements were missed or delayed, and the opening night curtain always went up as scheduled. Camels are loaded into the truck for departure.

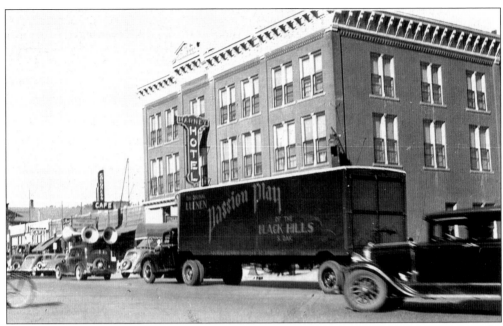

As the vehicles pulled into each city, the trucks headed for the theater to unload, while the actors dispersed to their various hotels. After the animals were housed, unloading and setup took place; then the wardrobe mistress arrived and began to unpack principal and Super costumes, the company manager rehearsed the Supers, and the organist rehearsed the choir. Pictured is one of the first Black Hills Passion Play touring trucks; note the loudspeaker preceding it, to advertise the forthcoming engagement.

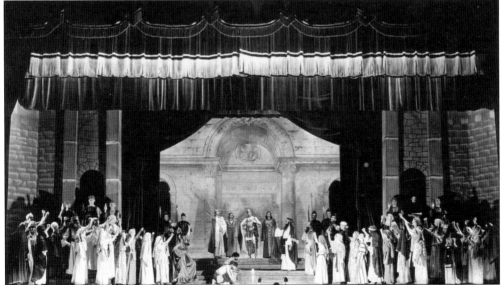

This photograph shows the Passion Play stage set as it appeared in an indoor auditorium. This picture is of the third Pilate scene. Kneeling before Pilate and the Christus are the two Thieves who would also go to the cross. Local Supers, recruited in each city, numbered around 50; a larger "mob" of 100 or more was used on the outdoor stages. The tours lasted until 1964, playing over 650 cities in 48 states and 6 Canadian provinces.

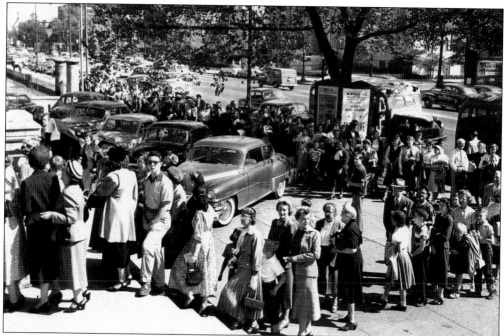

Crowds were so great in some cities that as many as five performances a day were done to accommodate them. The actors came into the theater at 10:00 a.m., had sandwiches and coffee between shows while the house was cleared out, and left at midnight exhausted, to head for their hotel rooms. Through the years there were repeat engagements, and some cities were visited as often as three times. Bookings were generally good, occasionally poor (if the committees had not been aggressive enough), and most often excellent. Pictured are people waiting in line at the theater in Dayton, Ohio; the second photograph shows students leaving after a special matinee performance in Los Angeles. (Black Hills Passion Play archives.)

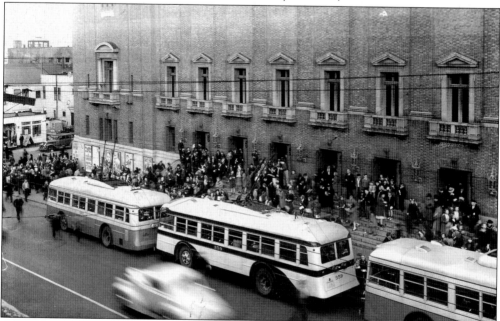

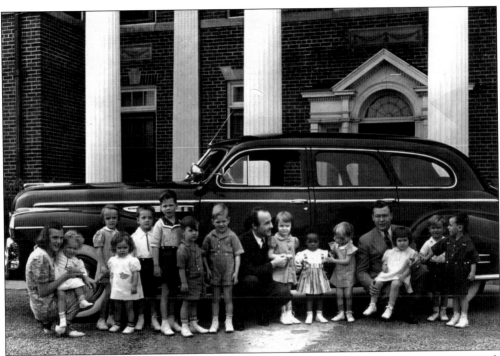

During the course of an engagement, the Meiers also paid visits to charitable institutions, such as an orphanage, in the above picture, and in the picture below, a children's ward in a hospital, accompanied by sponsoring committee members. The cities are unknown.

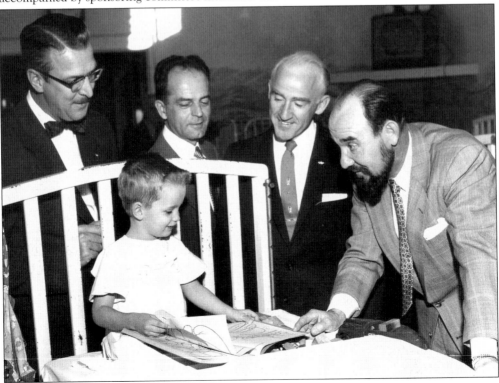

Josef Meier's energy was prodigious. After driving all night, he would often leap out of the car, check into the hotel, change, and rush off to speak at a luncheon or give an interview. If the show opened that night, he would stop by the theater to check on the Super rehearsal and setup, visit the animals, and was in his dressing room by 7:00 p.m. for makeup and costume. After the performance, around 11:30 p.m., he would return to the hotel to devote an hour or two to correspondence, working with the company secretary. Each of the advance men was required to submit a written report of his activities on a daily basis, and each of those communications warranted a response: advice, encouragement, or admonitions. Pictured are Josef and Clare Meier in their dressing room, getting made up for a performance. (Black Hills Passion Play archives.)

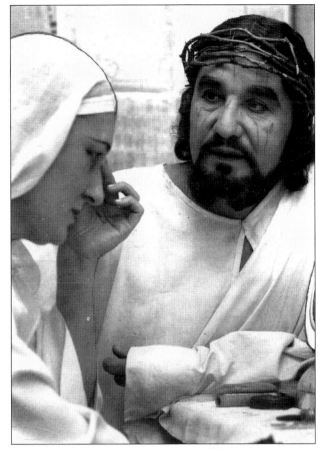

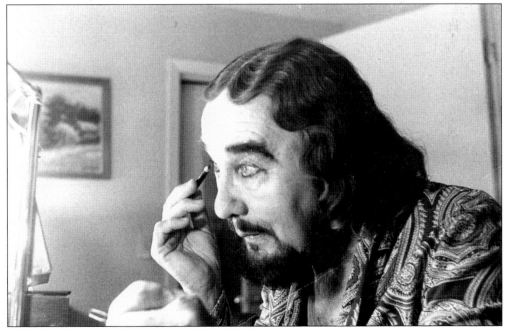

WESTERN UNION

1206-B

Charge to the account of _____ $ _____

CLASS OF SERVICE DESIRED	
DOMESTIC	CABLE
TELEGRAM	ORDINARY
DAY LETTER	URGENT RATE
SERIAL	DEFERRED
OVERNIGHT TELEGRAM	NIGHT LETTER
SPECIAL SERVICE	SHIP RADIOGRAM

Patrons should check class of service desired; otherwise the message will be transmitted as a telegram or ordinary cablegram.

A. N. WILLIAMS
PRESIDENT

NEWCOMB CARLTON
CHAIRMAN OF THE BOARD

J. C. WILLEVER
FIRST VICE-PRESIDENT

• CHECK

ACCOUNTING INFORMATION

TIME FILED

Send the following telegram, subject to the terms on back hereof, which are hereby agreed to

WANT A REPLY?
"Answer by WESTERN UNION"
or similar phrases may be
included without charge.

MR. C. W. FINNEY
827 WILLIAMSON BLDG.
PASSION PLAY HEADQUARTERS
CLEVELAND, OHIO

CONGRESSMAN FRANCIS CASE HAS JUST COMPLETED SPECIAL GOVERNMENT

ARRANGEMENTS ALLOWING US PLENTY OF GASOLINE FOR OUR OPERATION

FOR ALL CARS AND TRUCKS. REGARDS

VICTOR SPOUSE

8 THE CLEVELAND PRESS

Passion Play Furnishes Spiritual Impetus That Raises Hopes in Dark War Hours

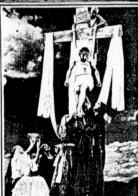

By FRANK STEWART
Church Editor

BALTIMORE, Oct. 31— With instructions to "write my own ticket," I came here to take a look at the Black Hills production of the Passion Play, which will be seen in Masonic Hall, Cleveland, Nov. 10-19.

Without reservation, I am going off the "deep end" to say it is something Catholics and Protestants in Greater Cleveland will want to see.

That's pretty strong language for one who has no connection with the promotion of the play, nor any interest in its financial success.

Bluntly, I think it is the very spiritual impetus Cleveland needs in these war times when people are looking toward religion.

It seems to me, visual representation of that Personal Sacrifice 2000 years ago, through a stage play, brings new hope in these dark war hours. I believe those who witness the Passion Play will feel that surge of hope and redemption.

The performances here are sponsored by the Cadoa Guild of Baltimore. I understand the Guild is an affiliate of the Catholic Daughters of America. Archbishop Michael J. Curley gave his unqualified indorsement and approval of the play.

I was here for an afternoon and evening performance in the Lyric Theater. The matinee was attended by more than 2000 children from parochial schools of the city.

• • •

YOU'LL agree 2000 boys and a girls can make a lot of noise. I wish you could have observed the reverent silence of the children as the scenes of Christ's life were unfolded before them.

That clinched my appraisal of the production. I questioned many adults for their opinion. Priests, preachers, business men and women agreed it was a great religious experience.

The Black Hills company is headed by Josef Meier who has gained international fame as a portrayer of the Christ. It is the Luenen version of the Passion Play, which I am told, has been

Top: The Last Supper . . . dramatic and poignant
Below: The Crucifixion . . . solemn stage scene

in existence 700 years.

It is not a glittering stage spectacle with the trappings of a Hollywood extravaganza—although the settings and lighting effects are notable.

Rather, it is a softly-colored series of scenes that reminds one of traditional religious paintings. Mr. Meier, with a resonant voice, seems to have stepped out of a frame as he plays the part of the Christus with dignity and gentleness.

Others in the cast, Clara Hume Meier, Mr. Meier's wife, as Mary; Eugene Stuckmann as John; Leland Harres as Judas, and all the others, lend a faithful "pic-

Much of the conversation is based on biblical text.

Choirs from Baltimore churches furnish musical accompaniment in connection with a score written for the organ. A cast of more than 100 is required and the costuming is authentic.

The play in Cleveland will be sponsored by the Churchmen's League and the general committee of indorsement includes persons of many faiths.

And that is all it should be—certainly the Passion Play, as presented by Mr. Meier, is free of sectarianism and denominationalism—it is the story of the Great Sacrifice . . .

Clara Hume Meier . . . as Mary

Josef Meier was sought-after as a public speaker, and his command of the English language was impressive. During the war years, he was asked to speak on the *Voice of America* to bring the message of democracy to Germany. As the United States entered World War II, rationing of gas and tires curtailed extensive tourist travel, and the Black Hills Passion Play was forced to cancel its summer seasons in Spearfish from 1945 to 1948. The government, however, felt that the play was a morale-building entity and gave it special consideration so that the production could continue to tour across the country. Pictured is the telegram received by advance man C. W. Finney confirming the news from South Dakota senator Francis Case concerning the availability of gas for the tour; also shown is an article from the *Cleveland Press* about the responsibility that the Black Hills Passion Play undertook throughout the country during the war. (At left, the Cleveland Press.)

WELCOME TO MAINE

JOSEF MEIER

and

BLACK HILLS PASSION PLAY

OFFICIAL PASS
STATE OF MAINE

Sumner Sewall
GOVERNOR

The Passion Play Museum contains many placards welcoming Josef Meier and the Black Hills Passion Play to a specific state (signed by the governor) or a city (signed by the mayor). These welcome cards, from the state of Maine and from Richmond, Virginia, are typical. Keys to the city were routinely presented, and Meier was occasionally asked to address a state legislature or city governing board.

WELCOME TO RICHMOND

JOSEF MEIER

and the

BLACK HILLS PASSION PLAY

OFFICIAL PASS
CITY OF RICHMOND

John R Britten
MAYOR

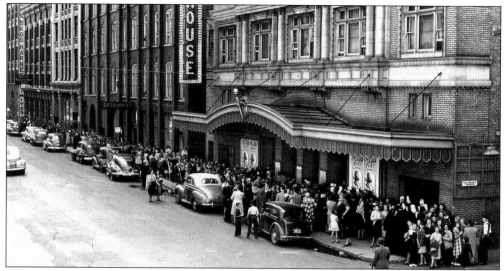

A typical touring season might take the company from New Orleans, Louisiana, to Mobile, Alabama, to Tallahassee, Miami, Orlando, St. Petersburg, Sarasota, and Pensacola, Florida, and back to Montgomery, Alabama; or Winnipeg to Regina to Calgary, to Edmonton, to Saskatoon, to Victoria and Vancouver in Canada. The year 1942 saw them traveling from St. Paul, Minnesota, to a two-week-long booking in Chicago's Civic Opera House. An audience lines up outside the Playhouse Theatre in Winnipeg, Canada.

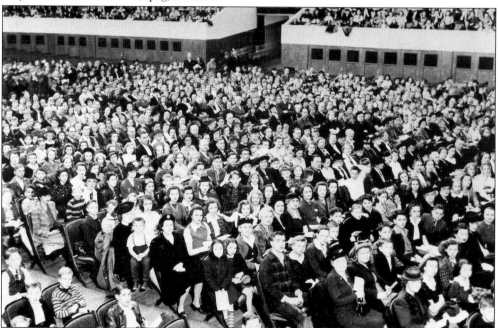

The "front of the house," or box office, had to be carefully monitored, and a Black Hills Passion Play representative was always present for the ticket count and division of receipts. For many years, Josef Meier's sturdy little German secretary, Ida Arnold, was in charge, and nothing questionable ever got by her. At just under five feet, Arnold was formidable, and she delayed the performance following the intermission if the ticket count was incorrect. Pictured is a full house in Constitution Hall, Washington, D.C.

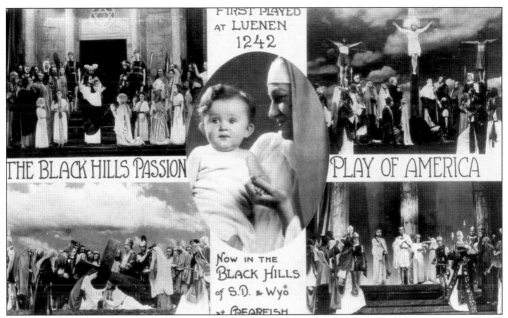

THE BLACK HILLS PASSION PLAY OF AMERICA

FIRST PLAYED AT LUENEN 1242

Now in the BLACK HILLS of S.D. & Wyo at SPEARFISH

Occasionally the company ran into problems in union-run theaters. The play carried its own stage crew to cope with the many quick changes in scenery, and local labor was superfluous. In some instances, pit orchestras came with the "house" package; the play carried its own organ to supply background music, rendering an orchestra unnecessary. Meier insisted that if union members were to be paid they must be present, so the orchestra and other crew had to sit in the basement for each full performance in order to collect their salaries. In this postcard composite of scenes from the touring performance, Clare Meier is center, holding the author.

Dressing room space was often at a premium. Sometimes rooms had to be hastily constructed at stage level from extra scenery flats and screens to accommodate quick changes. In one town, the backstage area was attached to a school structure, and actors in full costume had to access dressing rooms in the next building via a ladder and a door on the back wall. Camaraderie developed among the actors on tour, as many traveled together for 9 or 10 months annually on a continuing basis. Seen here is George Dayton as Caiaphas, the High Priest.

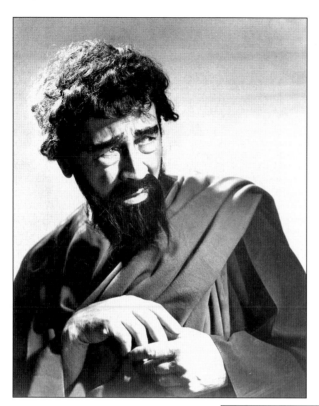

Pictured are several of the older actors who were with the Black Hills Passion Play for extended seasons. Seen here is Fred Hagen as Judas. (Black Hills Passion Play archives.)

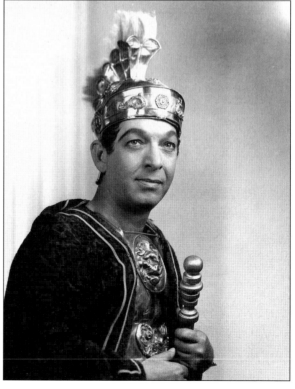

Character photographs were typically used for publicity purposes, either running in a newspaper with personal interviews or displayed on a billboard in a theater lobby. Pictured is Charles Arganbright as Pontius Pilate. (Black Hills Passion Play archives.)

As the only child in a company of adult actors, the author enjoyed having many surrogate "aunts and uncles." But when it was time to go onstage the actors were all business. Marathon car trips were routine, and Johanna had a sleeping place arranged on top of the luggage in the back seat of the car. The Meier family almost always toured with a dog, and on overnight "jumps" Johanna curled up on a garment bag, lulled to sleep by the late news or an all-night music station on the car radio. Stays in hotels required quiet behavior at all times, and Johanna was told, "You never know if someone has just checked in and needs their sleep." Restaurant meals were eaten without complaint. The author frequently gave interviews. It was generally a halcyon existence, but strict discipline was maintained at all times, and everything took second place to "the production." The author is pictured, both in costume during the touring years and in the Bethany scene, surrounded by acting "aunts and uncles."

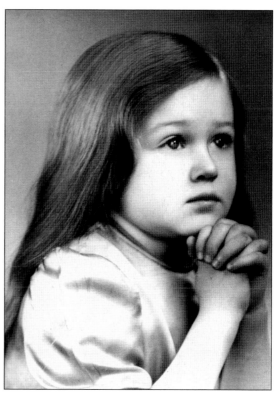

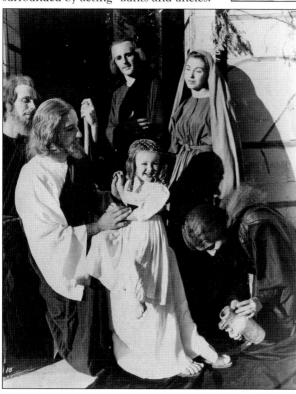

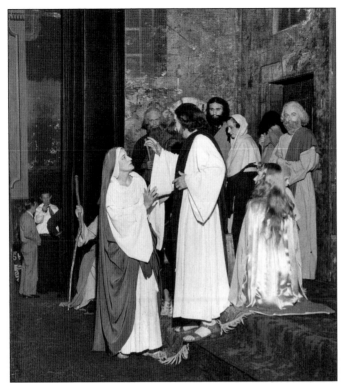

Pictured is an interesting backstage shot, taken during a performance. This was taken during the Bethany scene, in which Jesus bids farewell to his mother. Note the stagehands in the wings offstage at left. (The Milwaukee Journal.)

In 2000, the Passion Play went to Hamilton, Ontario, a suburb of Toronto, where it played in the 15,000-seat Copps Arena. Since it was also used as a hockey rink, a special platform had to be constructed covering the ice; this had been done several times during the earlier touring years and was always workable, although it provided a chilly stage for the actors to work on. Touring requires a special hardiness, and actors who have never experienced it have missed an intriguing and instructive aspect of their profession. This photograph is of setup in Hamilton, Ontario.

Four

THE ANIMALS

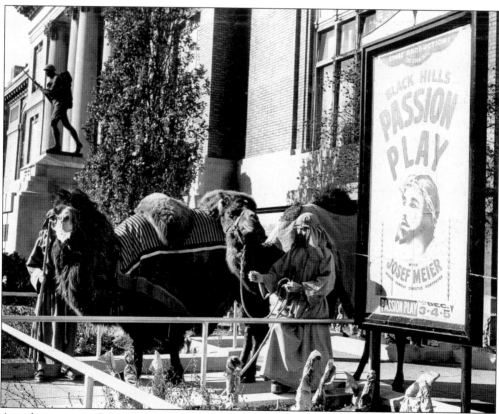

Any description of the Black Hills Passion Play must include the animals, an integral part of the production for 75 years. The first camels were acquired in 1941 from an exotic animal dealer in Thousand Oaks, California, who supplied livestock for the motion picture industry. Named for popular stars of the time, Fanny (Brice) and Loretta (Young) are pictured here on tour. The author's mother, Clare Meier, recalled standing by the camels in the wings while waiting to go onstage. As she entered, she suddenly realized that Fanny and Loretta had been chewing on her long hair, which now hung in slimy strings down her back.

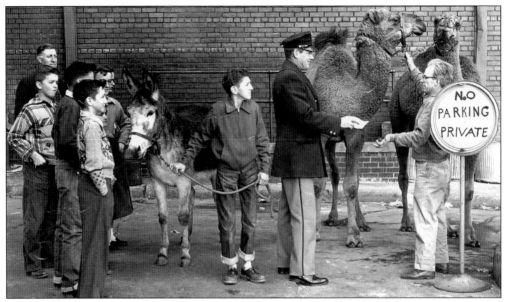

Fanny and Loretta toured for many years and adapted amazingly well to their unconventional lifestyle. They often made difficult entrances: up outdoor staircases, down long hallways, or on their knees through low doorways. The few times they were unable to reach the stage, they were restless and upset when they heard their entrance music. As they knelt patiently backstage, the author often sat on their backs and talked to them. The camels and the donkey provided many photo ops: a favorite setup was to tie them to a parking meter, with a policeman giving them a ticket. (Asheville Citizen Times.)

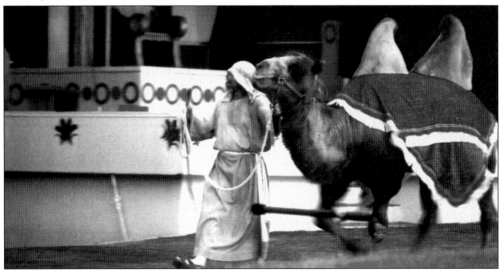

Over the years, the camels used have been almost exclusively Bactrian, or two-hump camels. Bactrians originated in the northern Gobi Desert and are adaptable to harsh winter conditions. They grow long woolly coats, similar to buffalo, which they shed in the spring and from which yarn for camel-hair coats is made. Bactrians are the only pack animal (aside from the elephant) capable of carrying 1,000 pounds and are still used for transporting goods through the Himalayas. Now listed as an endangered species, it is no longer possible to import Bactrians into the United States. The bull camel Fidelio, a magnificent Bactrian, is pictured "in costume."

The camels have always been raised and trained on the Black Hills Passion Play grounds. For several years during the author's childhood, an itinerant preacher visited every spring to train the camels to be ridden. The author remembers him galloping and bucking off across the pasture, his long black coattails flying.

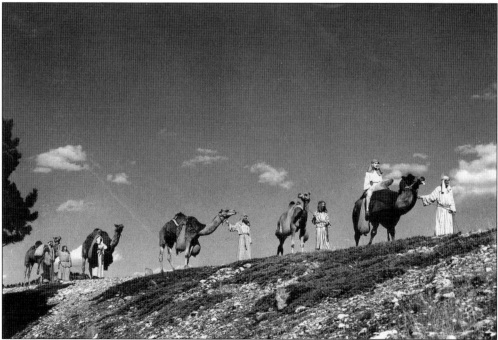

In their home in South Dakota, the camels enjoy large pasture areas and their own barns. Through the years, over 30 camels were born and raised, most of them living to a ripe old age. Part of the camel family is pictured "in costume."

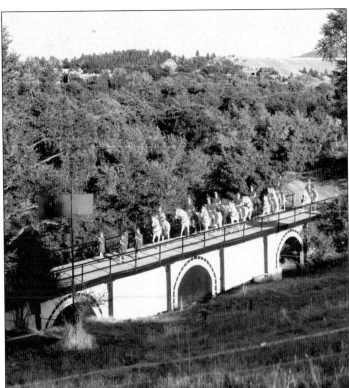

The extensive pastures surrounding the Spearfish Amphitheatre also provide a home for the donkeys and white horses, which are in the Black Hills Passion Play. The Roman Guards (Supers) ride nine white Arab/quarter horses, led by their Roman captain, Longinus. The Roman Guards are shown crossing the bridge to the Mount of Golgotha. (Black Hills Passion Play archives.)

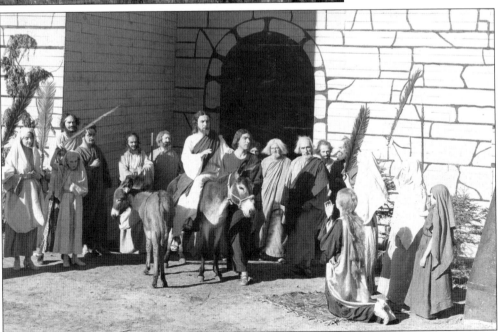

Five donkeys are used, including the one ridden by the Christus on his Triumphal Entry into Jerusalem (Palm Sunday). Additionally a darker colored horse is ridden by the captain of the Temple Guards. This is an early picture of the Triumphal Entry, with Josef Meier as the Christus riding the donkey. (Black Hills Passion Play archives.)

The donkeys are strong-willed individuals and great escape artists. They have made several forays through Spearfish to visit the Booth Fish Hatchery, a seemingly favorite destination, and on one memorable occasion arrived in the lobby of the Visitors Center, which had its doors wide open to admit the fresh summer air. The camels have occasionally made local visits as well. The author remembers answering the telephone to hear, "Say, your camels are in our back yard!" This picture ran in the local paper during the last donkey escape, which has several times taken place inexplicably on Good Friday. (Black Hills Pioneer.)

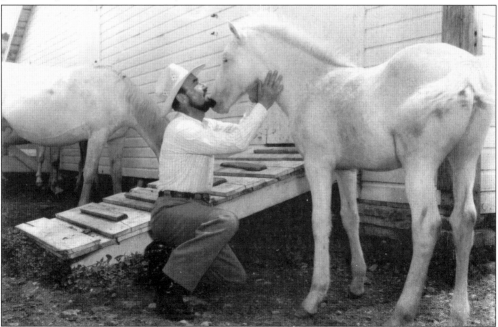

Josef Meier was a fine horseman and trained many horses himself. He assisted in many animal births, nursing weak colts and camel calves and often sleeping in the stable with them for a few nights to insure their survival. He was the only one to ride the white stallions, which were kept for breeding. Josef Meier is shown with the young colt Courage.

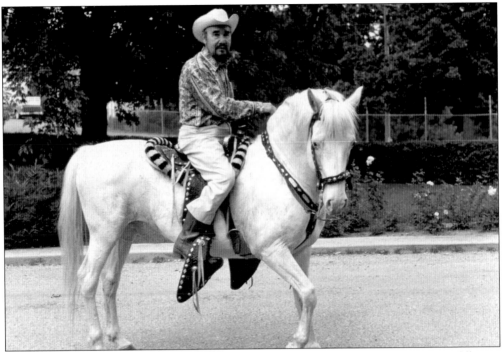

Here Josef Meier rides the mature stallion Courage. Meier's silver-trimmed parade saddle is a treasured memento.

Pictured is Meier helping one of the wobbly young camel calves to nurse. The births are occasionally complicated and sometimes require assistance.

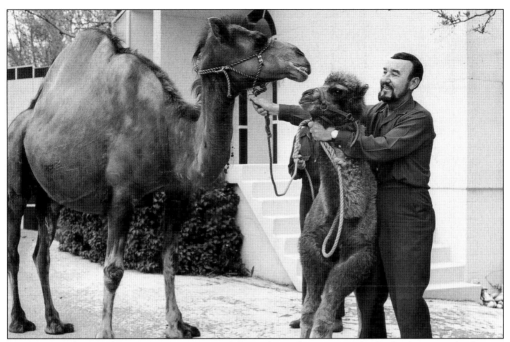

Young camels are always very curious and have been known to climb the steps to look into the temple while they are crossing the stage, or even clamber over the footlights to examine the audience. As they are gradually trained to be led, there are little spurts of bucking and pulling, and the camel handlers have to be prepared with a strong arm. Meier is shown here with a rambunctious young camel. (Black Hills Passion Play archives.)

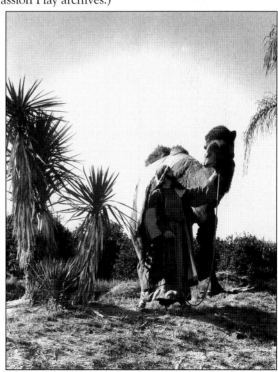

One of the largest bull camels through the years was Ike, so named because he was born the summer Pres. Dwight D. Eisenhower spent his summer vacation in the Black Hills.

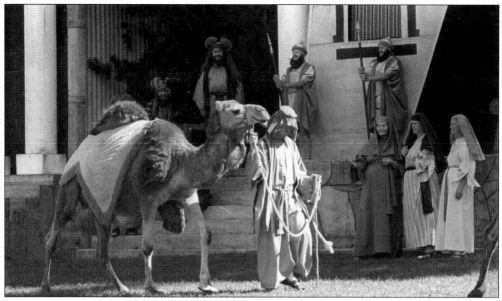

Lydia, one of the few dromedaries (one-hump camel) owned by the Black Hills Passion Play, appears in her scene during a Florida performance. She became particularly famous because she gave birth to one of her calves during the Good Friday matinee in Florida, attended between scenes by Judas, Mary the Mother, and the amphitheater manager. (Gilman, Lake Wales, Florida.)

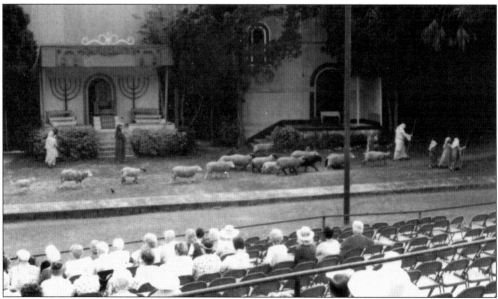

A small herd of sheep is also used, and lambs are a great favorite with summer audiences. Occasionally the sheep get distracted and do not run their normal course across stage and down to the barn. The show goes on, but costumed shepherds quietly herd the sheep back down to containment. Shepherding is one of the earliest assignments for Supers. Extra rehearsals are called to "run the sheep" before the season opens in the spring. Together with the ever-changing weather, the animals provide one of the strong elements of the realism that is an intrinsic part of Black Hills Passion Play performances.

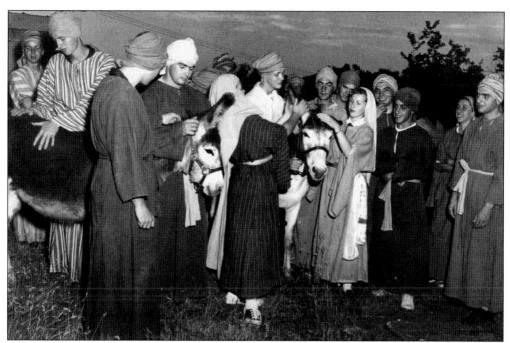

Interaction with the animals has always been a highlight for youth participating as Supers. They start out as shepherds, with adult assistance; they graduate to become donkey leaders, taking donkeys across stage with arriving merchants and their goods. Those in the most coveted position ride white horses, playing Roman Guards, a true "coming of age." This role is restricted to experienced riders. Pictured are members of a youth fellowship organization from Rapid City Air Force Base who came to participate as Supers. (Black Hills Passion Play archives.)

A youngster is pictured with one of the camel calves; the camels have also been ridden in local parades as a publicity stunt. Hollywood borrowed one of the females, Titze, for use in the film *Hawmps*, which garnered her a publicity picture in the *New York Times*. (Florida State News Bureau.)

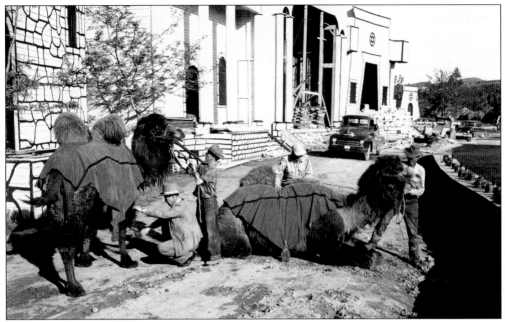

All the animals must be rehearsed before the opening of the summer season, having come in from nine months out to pasture. They have to be reacquainted with their music, the sound of the crowd yelling (either "Hail Hosanna!" or "Crucify Him!"), and the recorded thunder and lightning used during the Crucifixion scene. Seen here are camels in rehearsal early in the spring with Josef Meier and the animal handlers. (Black Hills Passion Play archives.)

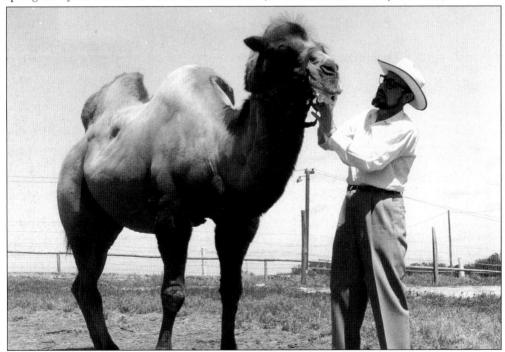

Pictured here is Josef Meier with the bull camel Fidelio, after he has shed his heavy winter coat for the summer. (Publicity Division, South Dakota Department of Highways.)

Five

THE PASSION PLAY
AT HOME

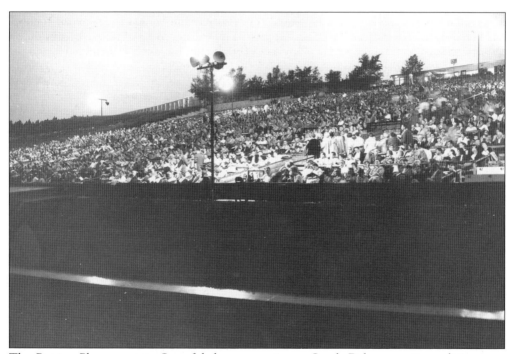

The Passion Play season in Spearfish has grown into a South Dakota tourist tradition, now in a fourth generation of families in attendance. Some visitors were brought to see the play as children and are now bringing their own grandchildren or great-grandchildren to follow the family tradition. The play can be a great educational tool, bringing vividly to life the stories that have been taught in Sunday school or at home. Here a typical audience assembles before the performance begins.

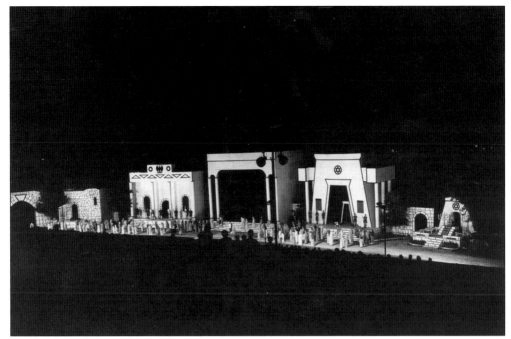

The realism of the setting is always a cause for comment, "I felt like I was really there when it took place" or "The night I saw it there was a real thunderstorm!" Natural phenomena are an important part of the spectacle. Sometimes in early June, low-hanging clouds gather behind the Mount of Golgotha where the Crucifixion is depicted. The spotlight illuminating the center, or Christus cross, will cause the giant shadow of a cross to be projected on the clouds in the background—a special effect no human hand could achieve. Shooting stars and northern lights are sighted regularly too. This night shot was taken during the early years.

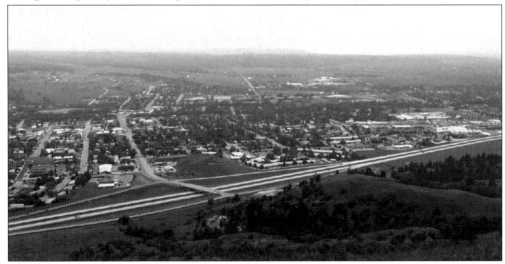

The summer season is equally a community tradition. Through the years, the Black Hills Passion Play, Black Hills State University, and the local sawmill have been the three balancing constants that helped provide growth and development to the town of Spearfish. Interstate 90 arrived, crossing South Dakota from east to west, with four exits into Spearfish. Above is an aerial shot of Spearfish showing the interstate highway, which was constructed in 1973.

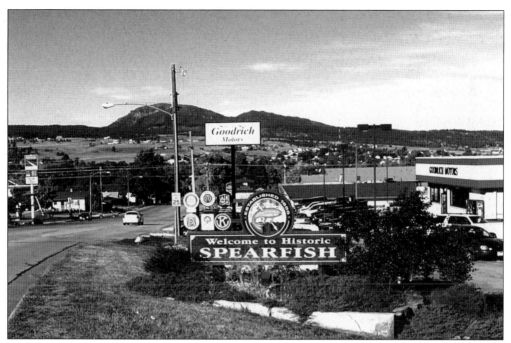

National chain motels and ethnically diverse restaurants now serve the traveling public and local residents, and the town provides quality shopping, art galleries, and two golf courses for all to enjoy. This is a photograph of modern Spearfish Main Street, courtesy of the Spearfish Chamber of Commerce.

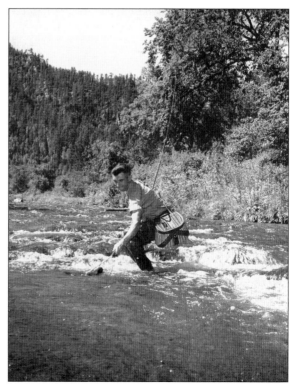

Outdoor recreation is everywhere inviting, with fishing, hiking, trail rides, and breathtaking scenery to be savored. Pictured is a visitor enjoying the exceptional fly-fishing in Spearfish Creek, where sizable rainbow trout can be caught.

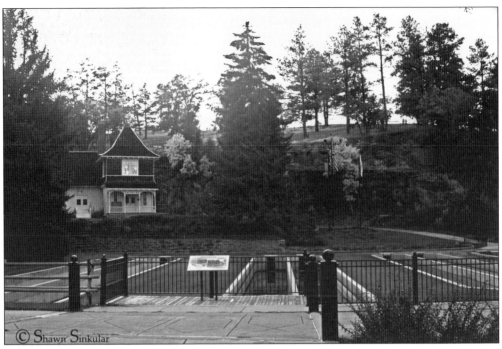

© Shawn Sinkular

Other attractions have sprung up, such as the High Plains Western Heritage Museum, the D. C. Booth Historic Fish Hatchery, the Spirit of the Hills Wildlife Sanctuary, and the Dolls at Home Museum. Cultural activities are available, with community theater, concerts, and outdoor summer festivals. Pictured are D. C. Booth Historic Fish Hatchery and a brochure for the more recent Spirit of the Hills Wildlife Sanctuary.

The little town of 1,800 inhabitants, which took a chance on an unknown entity, and Josef Meier's enormous leap of faith in choosing it have more than proved themselves. Spearfish now boasts nearly 11,000 residents, and new building and construction are booming. Spearfish has gained recognition in numerous articles and books as one of the best small towns in the nation to live. Attractive residential streets and spectacular scenery draw visitors and new residents. It has become a popular retirement community as well, with numerous residential apartments, assisted living facilities, and extensive health care facilities. The image at right shows the face of a map with detailed information about the community and its entities, printed by the local chamber of commerce, and the one below shows the back of Black Hills Passion Play stationery, advertising Spearfish as a tourism destination.

Spearfish

South Dakota

"Best of the Black Hills"

Spearfish Area Chamber of Commerce
and Convention & Visitors Bureau

115 E. Hudson, P.O. Box 550
Spearfish, SD 57783
(605) 642-2626

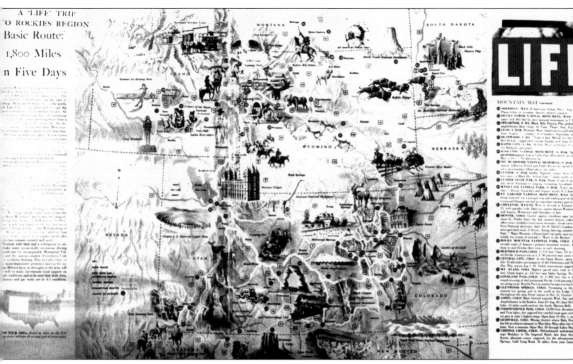

The Black Hills themselves have become a national and international tourist destination, just as the tourism pioneers predicted. To date, over 10 million people have witnessed the Black Hills Passion Play, bringing prosperity and recognition to this little western town. This image is of a western tourist "destination" map printed by *Life* magazine in the 1950s. The Black Hills Passion Play is depicted by the three crosses in the upper right-hand corner of the map.

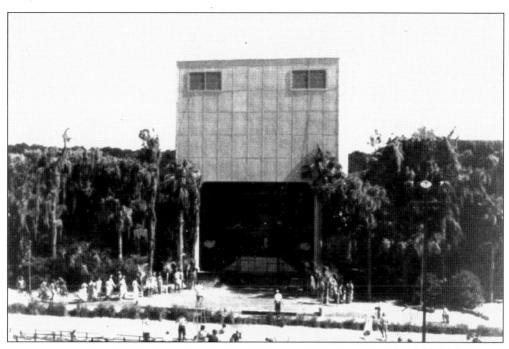

In 1953, a similar phenomenon occurred when the play was invited to establish winter quarters in Lake Wales, Florida. As had happened before, a committee of local businessmen approached Josef Meier, inviting him to their city and offering to build an outdoor theater for winter performances. As the cross-country tours were becoming increasingly arduous, it seemed like a good opportunity, and the plans began to unfold. This second amphitheater was built in the midst of an orange grove, in the popular central Florida corridor along Highway 27. Pictured is the new Lake Wales Amphitheatre under construction.

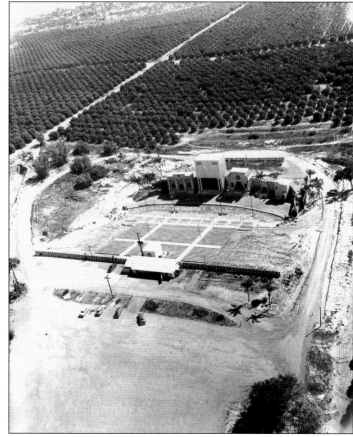

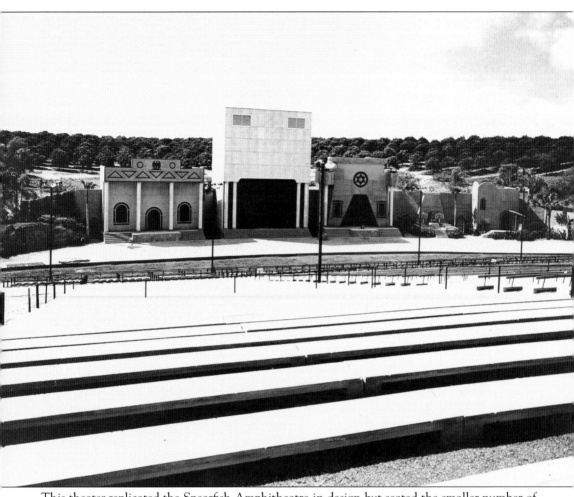

This theater replicated the Spearfish Amphitheatre in design but seated the smaller number of 3,500 in the audience. The surroundings were lush, and the performances ran from mid-January through Easter. The Florida winters were generally mild, and the scent of orange blossoms filled the air during the season. (Gilman, Lake Wales, Florida.)

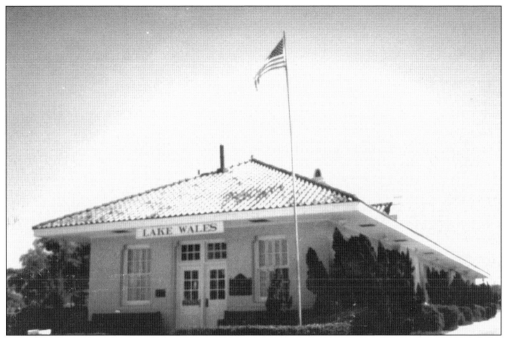

Initially the railroad came into Lake Wales, and "Passion Play trains" became a popular item with the older retirees in the state. They arrived in the late afternoon from the west and east coasts, bringing hundreds of people in for dinner and a performance and then carrying them home again afterward. This is a picture of the original Lake Wales depot, which has since become a museum for local history.

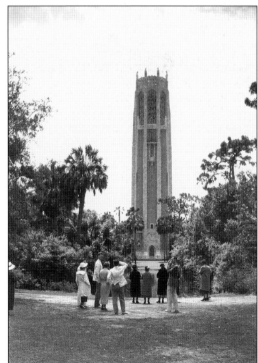

Lake Wales is in the Highlands region of Florida, in the midst of the citrus belt. It is a charming small town with a permanent community of winter residents. Among its attractions is pictured the Bok Singing Tower and Gardens, built by wealthy publisher/philanthropist Edward Bok.

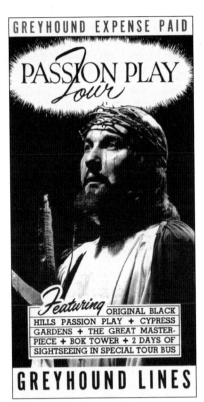

Church and youth groups from all over the state came by bus to see the play. The opening season in Lake Wales was 1953, and the company continued performances there until 1998. Greyhound Bus Tours offered Black Hills Passion Play packages, which included other central Florida attractions.

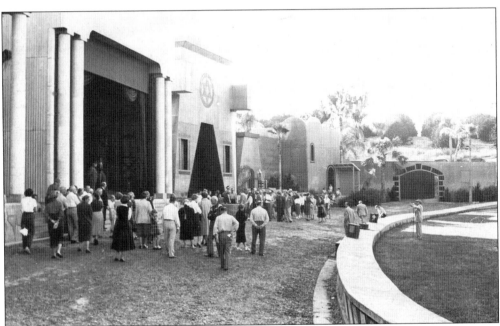

As in Spearfish, the local population proved to be enthusiastic extras. One nearby community, Nalcrest, was comprised of retired postal workers who were especially supportive Supers; many never missed a performance through the years. This picture is of a rehearsal onstage in the Lake Wales Amphitheatre.

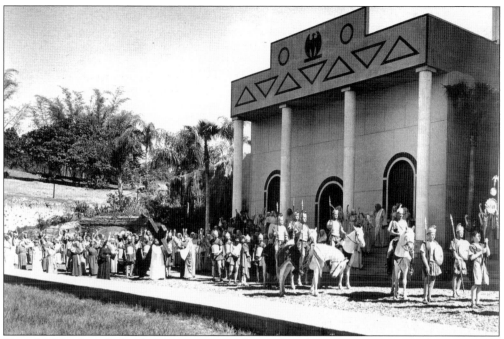

Here the March to Golgotha is seen as it was depicted in the Lake Wales Amphitheatre. Due to the reduced size of the amphitheater, the Crucifixion scene took place on the center stage, rather than on an adjacent hillside, as in the Black Hills.

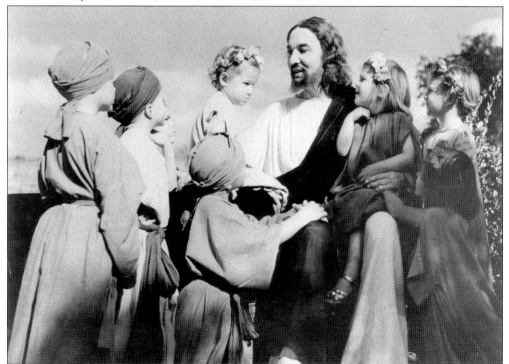

This picture of local children participating in the Bethany scene with Josef Meier as the Christus became a popular postcard. (Gilman, Lake Wales, Florida.)

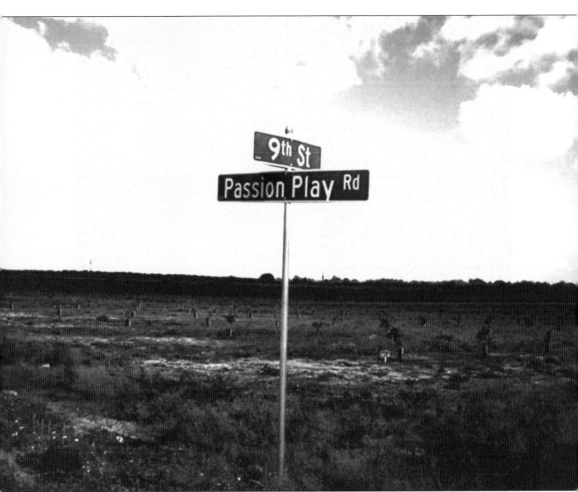

Several factors came into play leading to an eventual end to the winter season of the Black Hills Passion Play in Florida. In 1971, Disney World opened in Orlando, shifting the attention of the visiting public away from the formerly popular central Florida corridor. People flew into Orlando to spend vacation savings at the new attractions and departed having seen little of the real Florida. Elaborate artifice and shopping malls replaced the tranquil appeal of natural settings. New lifestyles did not seek out the spiritual experience and outdoor setting offered by the Black Hills Passion Play. After 45 amiable years, the Lake Wales Amphitheatre, under ownership of a local committee, was not able to sustain the necessary maintenance of the facility, and the outdoor set became unsafe for the actors and the audience. Unable to retain the integrity of the play and unwilling to present it under unfavorable conditions, the Black Hills Passion Play company regretfully ended the winter seasons in 1998, leaving the amphitheater to be destroyed several years later by hurricanes. Only a signpost remains to indicate where a vital 3,500-seat amphitheater once stood.

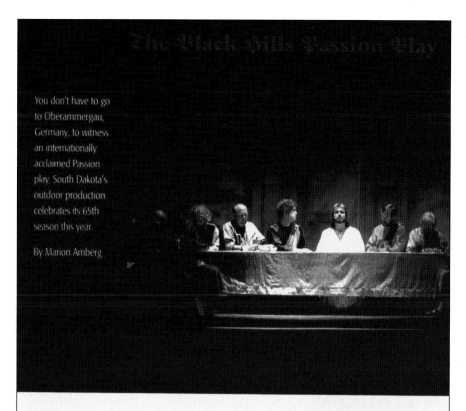

The Black Hills Passion Play

You don't have to go to Oberammergau, Germany, to witness an internationally acclaimed Passion play. South Dakota's outdoor production celebrates its 65th season this year.

By Marion Amberg

HEN THE LATE Josef Meier walked on stage in his white robe, he seemed to transcend life. And no wonder: For more than 9,000 performances of the Black Hills Passion Play, Meier portrayed the Christus (German for Christ).

Like Jesus, Meier rode a donkey amidst shouts of "hosanna." He washed the dusty feet of his apostles and fell under a 150-pound cross. When Meier cried out, "It is finished," at Golgotha, audiences sat stunned. The actor's spirit was infused with the Passion of his Savior.

Depicting the last seven days in the life of Christ, the Black Hills Passion Play is a marvel of outdoor pageantry and religious drama.

Interdenominational Cast

This centuries-old drama, which made its American debut during the Great Depression, celebrates its 65th season in Spearfish, South Dakota, this summer. It is the longest-running professional Passion play in the nation.

"I look at this as a mission," says Charles Haas, 32-year veteran actor of the play. "It's not the jungles of Africa, but maybe it's in harder jungles—the jungles of people's hearts."

With Lookout Mountain as a backdrop, the play's magnificent three-block-long stage (the nation's longest)

For more than 9,000 performances, German immigrant Josef Meier portrayed Christ in this play that dates back to 1242.

36

Aside from several of the aforementioned Canadian tours, the Black Hills Passion Play now concentrates its performances in Spearfish. Although the official Black Hills Passion Play season runs through June, July, and August, the work of preparation goes on all year long. New brochures and programs must be formulated, proofed, and printed; the next season's cast must be auditioned and contracted, and the constant flow of reservations processed. Most bus tours make their plans up to a year in advance, often immediately after attending a performance, and other groups also make their arrangements early. Black Hills Passion Play offices are open year-round, although the actual staffed box office opens in May to begin pulling tickets and filling the mail orders. During the off-season, advertising campaigns are mapped out and informational stories placed in various publications. This image reflects a story that appeared in the *St. Anthony Messenger* in 2004. (St. Anthony Messenger.)

As soon as weather permits, maintenance work resumes. Harsh winter weather takes its toll, and there is always repair work and painting to be done. When rehearsals begin in the spring, props and set pieces are refurbished. The Black Hills Passion Play constructs all its own wardrobe—over 200 costumes are worn per performance. Laundry, dry-cleaning, repair, and construction are ongoing, both for actors and animals—trappings for the horses and camels take a beating too. Josef and Clare Meier confer with the wardrobe mistress backstage. (Black Hills Passion Play archives.)

The Visitors Center and museum require a thorough going-over, and the gift shop gets restocked. Longtime amphitheater manager Harold Rogers played the role of Pontius Pilate during the early touring years and then remained on to work with Josef Meier as amphitheater manager.

The new staff for summer must be organized as well—box office personnel, ushers, and parking staff for three large parking lots. The backstage tour guides are trained and run practice tours with the company manager to check for accuracy of information and presentation. Another longtime amphitheater manager, Klink Garret worked with Meier until the period of the latter's retirement in 1991. (Black Hills Passion Play archives.)

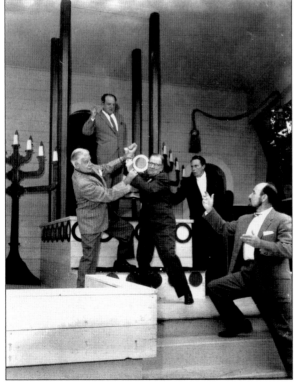

Rehearsals begin several weeks before the season opens—an arduous work period. For actors who have never performed in outdoor theaters, concepts of diction, vocal projection, and timing are vital. As there is no break between scenes, cues and distances from entrances and exits must be carefully coordinated between lighting and sound technicians and the organist. Communication between backstage and the front of the house is constant during performances. Director Josef Meier, lower right, rehearses the Sanhedrin scene during the 1950s.

What if it Rains?

<u>Light Rain:</u>
We will play through any light precipitation. In case of a heavy shower, we will call an intermission and ask the audience to seek shelter. We will flash the lights when we are ready to resume.

<u>Rain-outs:</u>
If the performance is officially cancelled before the Last Supper Scene, an envelope will be provided to facilitate the exchange of tickets by mail for any future performance or for a refund. REFUNDS ARE NOT GIVEN AT THE BOX OFFICE.

<u>Cancellation:</u>
The decision to cancel a performance due to rain is never made before curtain time. We reserve the right to delay the start of a performance if we feel the rain will end shortly.
If we have played through the Last Supper Scene, it will be considered a complete performance and no refunds will be made; however, if you feel unable to stay when the performance is presented during adverse conditions, you may present your stubs to the box office to be initialed and we will honor them for admission to any future production.

Weather changes can be rapid and intense, but the play is seldom cancelled due to rain. Throughout performances, contact with area weather stations is maintained, and the arrival of inclement weather is factored well in advance. The amphitheater has sheltered seating for 1,000, and performers are prepared to continue through moderate precipitation. Occasionally, if the rain is heavy, a 10-to-15-minute intermission will be called, and the play resumes as soon as the storm is past. Sometimes it is difficult for travelers from other parts of the country to realize how localized and fast-moving the weather is, and if it is raining a few miles away, it can be completely clear in Spearfish. The weather can add a great deal of drama to a performance, but it is demanding on the actors' concentration. The official rain policy of the Black Hills Passion Play is displayed throughout the box office area.

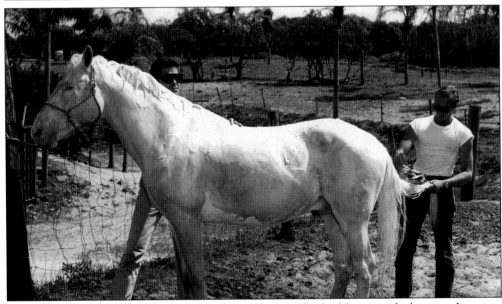

Preperformance setup requires sweeping, opening up the buildings, and clearing the stage of any windblown debris that may have accumulated, setting props and costumes, opening 105 footlights, checking sound equipment, and bringing the animals in from pasture—the horses to be curried and saddled, the camels and donkeys to be given trappings, the sheep to be herded into their pen, and even the pigeons to be caught and placed in their breakaway cage. Here horses are washed and groomed before a performance. (Gilman, Lake Wales, Florida.)

By an hour before curtain time, the actors are in costume and makeup, and the Supers who will be participating that evening arrive. Assignments are made for who will play a priest or disciple, a water carrier or a merchant. Even the children who have volunteered to be "pooper scoopers" need to run through their duties. Pictured are Supers in costume backstage. (Black Hills Passion Play archives.)

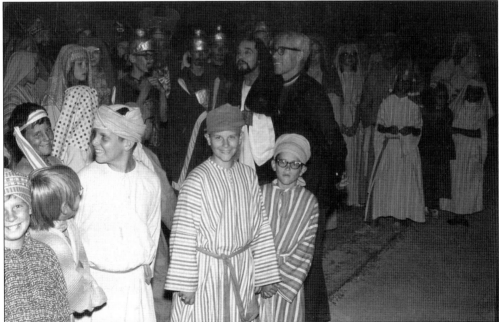

By the time "half-hour" is called, the audience has begun to fill the seats, and the preperformance organ concert is well underway. The final count of Disciples is made (of course there must always be 12), the Temple Dancers run through their routine, and any notes or announcements are given to the performers. (South Dakota Department of Highways.)

By the time of the call for "Places!" everybody must be ready, and the many elements of production prepared to run like clockwork. Routine and attention to detail are the key in making such a huge outdoor drama run smoothly, and essentially the same procedures have been working for nearly 70 years.

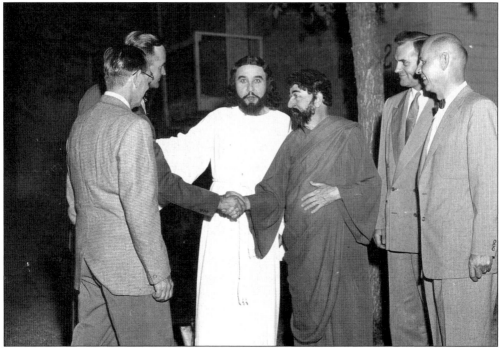

The Black Hills Passion Play has routinely been visited by South Dakota governors. Most of the state senators and representatives have taken time to attend the Black Hills Passion Play as well. Josef Meier presents Fred Hagen, portraying Judas, to former governor Sigurd Anderson.

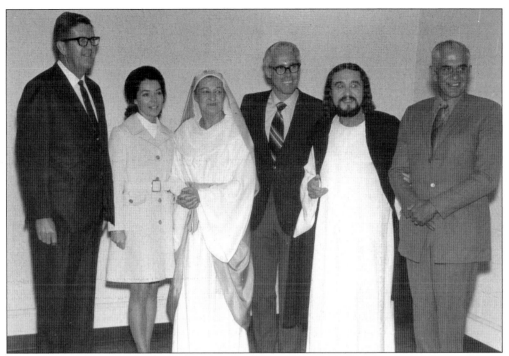
The Black Hills Passion Play hosts a special "Governor's Night" for each administration. Gov. Frank Farrar is pictured between Clare and Josef Meier following a performance.

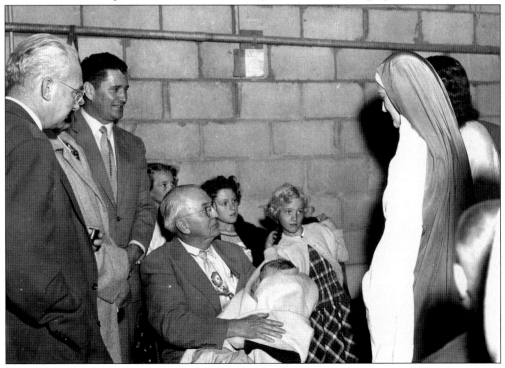
World War II flying ace and South Dakota governor Joe Foss, standing second from left, greets Clare and Josef Meier with his party following a Black Hills Passion Play performance.

South Dakota governor Richard Kneip talks with Josef Meier; Clare Meier stands in the background.

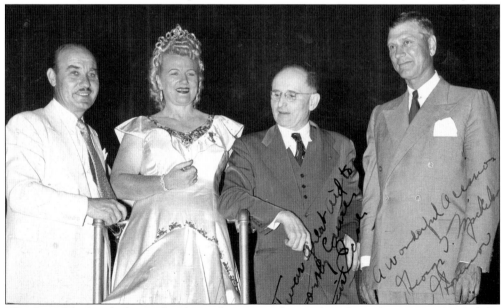

The Spearfish Amphitheatre has been the scene of many benefit performances. One of the highlights was a concert given by Australian opera star Marjorie Lawrence. Lawrence was struck by polio at the height of her career, but after several years of treatments, she recovered sufficiently to perform again, either seated or standing on a special platform, wearing leg braces. Josef Meier had witnessed Lawrence's comeback at the Lyric Opera in Chicago and went backstage to invite her to sing a benefit for the South Dakota Crippled Children's Hospital. Pictured here are Josef Meier with Lawrence, South Dakota senator Francis Case, and Gov. George T. Mickelson. (Black Hills Passion Play archives.)

Lawrence returned several years later to do a second concert, which also included the appearance of Jean Hersholt and Rosemary DeCamp, of Dr. Christian radio fame.

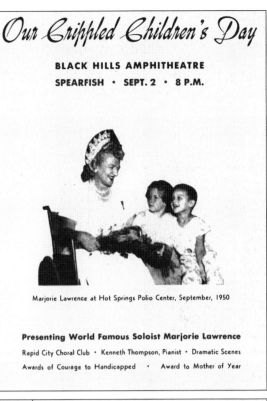

Our Crippled Children's Day

BLACK HILLS AMPHITHEATRE

SPEARFISH • SEPT. 2 • 8 P.M.

Marjorie Lawrence at Hot Springs Polio Center, September, 1950

Presenting World Famous Soloist Marjorie Lawrence

Rapid City Choral Club • Kenneth Thompson, Pianist • Dramatic Scenes

Awards of Courage to Handicapped • Award to Mother of Year

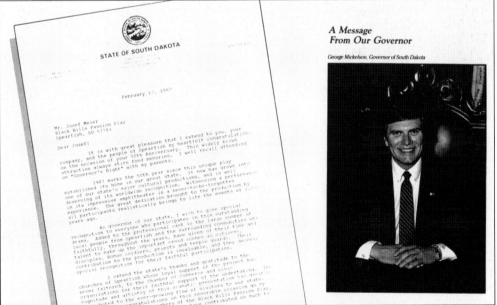

The first Governor Mickelson was also the father of a subsequent South Dakota governor, George S. Mickelson. The latter had been brought to see the play as a child by his father, who afterward wrote that he wished "every man, woman and child in South Dakota could see the Play" (July 1948). His son later wrote a letter of dedication, which was included in the program honoring the 50th anniversary of the Black Hills Passion Play in Spearfish.

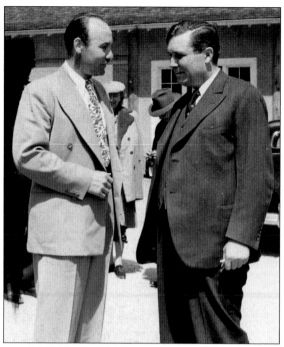

Among the many distinguished visitors who came to see Josef Meier was Wendel Wilkie, presidential candidate of 1948, at the time of his visit to the Black Hills. (Black Hills Passion Play archives.)

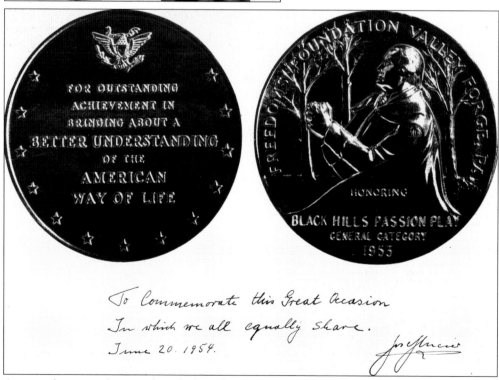

To Commemorate this Great Occasion
In which we all equally share.
June 20. 1954.

Among the many honors the Black Hills Passion Play has brought to Spearfish was the National Freedoms Foundation Award, presented in 1953. This award is given "For Outstanding Achievement in Bringing about a Better Understanding of the American Way of Life" and was accepted by Meier on behalf of the Black Hills Passion Play and the community of Spearfish.

Another prestigious distinction was the Lifetime Achievement Award presented by the Institute of Outdoor Drama. The Black Hills Passion Play is one of some 90-member theater companies of this organization from across the country, which include historical, religious, and Shakespearean festivals. Meier is shown here displaying this award.

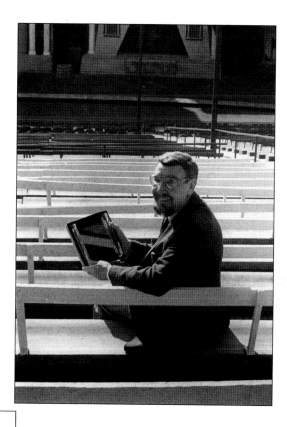

The Reader's Digest

29TH YEAR APRIL 1950

An article a day of enduring significance, in condensed permanent booklet form

A 700-year-old Passion Play driven out of Germany takes triumphant root in South Dakota

Gethsemane in the Black Hills

Condensed from Farm Journal Paul Friggens

WHILE LIGHTNING stabbed at the surrounding South Dakota Black Hills, thousands of people from nearly every state seated themselves in the vast natural amphitheater to look down on a huge outdoor stage and marvel at the beauty of its backdrop — majestic Lookout Mountain. Darkness came. Suddenly the hillside was hushed. A spotlight found the mammoth stage where a solitary figure stood radiant in robes of white.

Josef Meier raised his arms in the manner of the Man of Galilee and began his prologue to the Black Hills Passion Play. "Oh, ye children of God," he intoned, "open your hearts and receive with childlike confidence His great message. . . ."

Josef Meier

Halfway through the dramatization of Christ's last week on earth, rain began to fall. Few persons in the audience had any shelter, and yet none of them left.

Soon water had collected in pools before the palace of Pilate where Jesus stood on trial. The mob, crying, "Crucify him! Crucify him!" slipped in the muddy streets. At length, the Christus shouldered the 160-pound cross to stumble up rocky Calvary, was crucified and borne to his tomb. After the triumphant strains of Handel's "Hallelujah Chorus," at the end of the two-and-a-half-hour performance, men, women and children stirred themselves back to reality, to walk silently to their automobiles.

This experience

Farm Journal (April, '50), copyright 1950 by Farm Journal, Inc., Washington Square, Philadelphia 5, Pa.

Many national publications have featured the Black Hills Passion Play; among them are the *Saturday Evening Post* (1943), *Time Magazine*, *Newsweek*, and *Reader's Digest* (1950), pictured here. (Reader's Digest.)

89

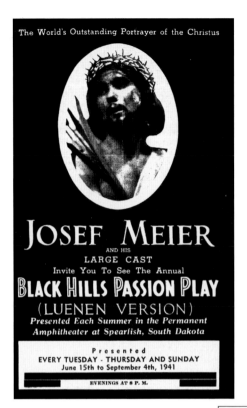

Pictured here are two early versions of the Black Hills Passion Play program. The first is from 1939, the opening season in Spearfish; the second one from about 1941.

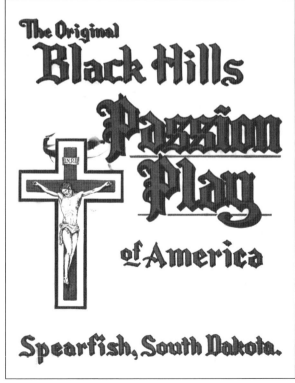

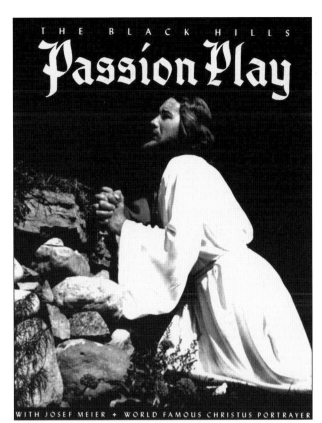

Shown are two more Black Hills Passion Play program covers; the first is from 1949, and the second is the current 2008 version.

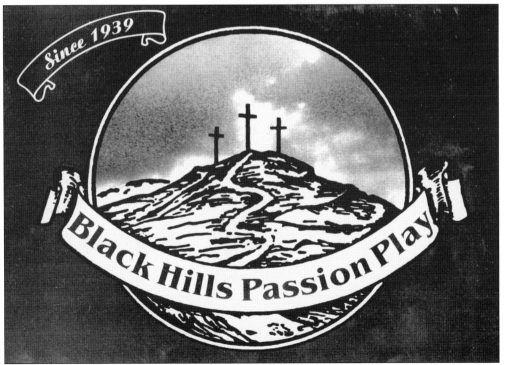

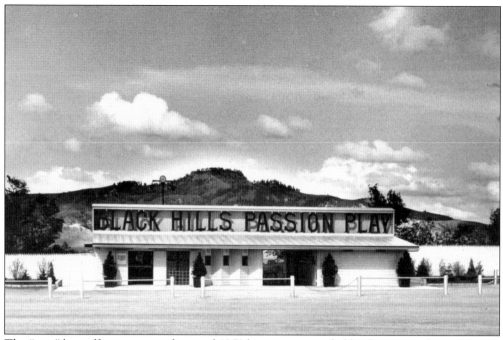

The "new" box office was erected around 1950 but was superseded by the current larger Visitors Center, built in 1973. This building now houses not only the box office and five ticket windows but a lobby with selections of tourist literature for vacationers to peruse and a gift shop, as well as the museum exhibits upstairs, which are a part of the daily backstage tours.

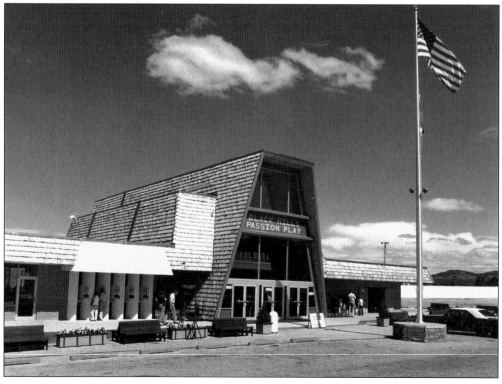

Six

THE MEIER FAMILY

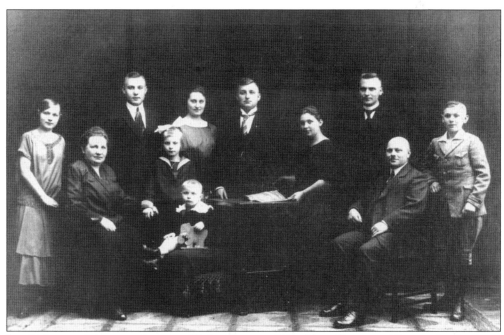

Josef Johannes Meier was born in 1904 in Luenen, Westfalen, Germany. He was the third son in a family of nine children. He had lived as a youngster through World War I. Life in Germany following World War I continued to be difficult, and economic conditions were perilous as currency fluctuations devalued the German mark, causing widespread unemployment. Politically Germany was also in turmoil, reeling from the devastation of the war, the disastrous Versailles Treaty, and the loss of self-respect among its people. Into these chaotic circumstances came Adolf Hitler, with promises of the restoration of German national pride and power. This picture shows the Meier family sometime after the World War I; Meier stands in the back row on the left side of the photograph, behind his mother.

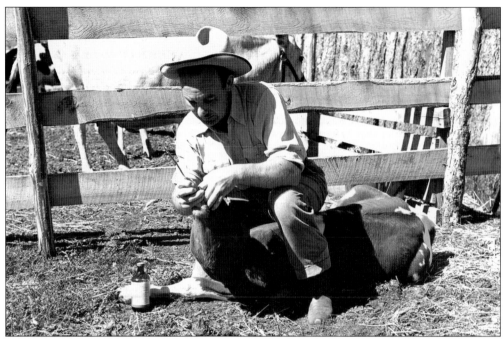

As a young man, Josef Meier was interested in drama and active in sports—swimming and horseback riding being his two favorite diversions. Always fond of animals, Meier developed a knack for healing injured pets and actually entered medical school with the idea of becoming a doctor or veterinarian. He is pictured here in later years doctoring a calf on his ranch in Spearfish.

By 1932, Meier was enrolled as a medical student, but his life changed radically when he agreed to take a small company of players to America to present a passion play. Originally this was projected to be just a short tour, but as religious plays had been banned in Germany, it became apparent that in order to survive, the production would have to remain in America and potentially relocate there. Pictured are some original German cast members.

An energetic young man with grand personal vision and dreams of a democratic lifestyle, Meier found the culture in the United States appealing. He made his first great gamble, deciding to remain in the country although it was in the midst of the Depression, and the company faced a hard struggle to survive. He eked out a living working odd jobs between engagements. Meier was offered the directorship of the German Theater in Chicago but declined in order to pursue his true calling. This early program was used when the play was sponsored by the St. Adolphus Church in Chicago.

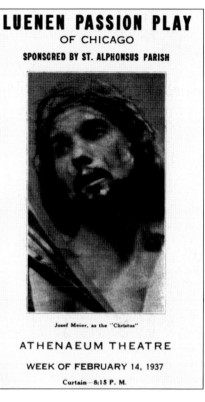

LUENEN PASSION PLAY
OF CHICAGO
SPONSORED BY ST. ALPHONSUS PARISH

Josef Meier, as the "Christus"

ATHENAEUM THEATRE

WEEK OF FEBRUARY 14, 1937

Curtain—8:15 P. M.

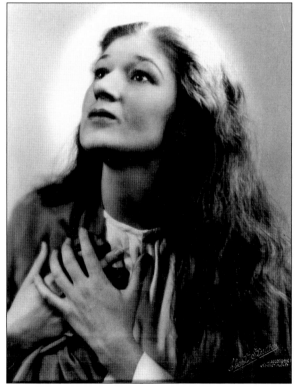

In preparation for an engagement in Wilmington, Delaware, Meier needed a new Mary Magdalene. He went to the Bennett Theatrical Agency in Chicago where he discovered Clare Hume, a beautiful young actress with long, reddish-blonde hair. Hume was hired on the spot, although her agent, Mrs. Bennett, who had also represented her parents, called Hume's mother first to see if she approved of the young woman leaving town with a touring company. The young Hume is pictured as Mary Magdalene.

Clare Hume came from an illustrious American theatrical family. Her parents, Edward Hume and Frances Cossar, were stars in musical comedy, and Clare was raised in a typical backstage environment. Edward Hume, a comedian and a dancer, came up through the ranks during the early 1900s via Boston, where he had emigrated as a young boy from Edinborough, Scotland. Edward Hume's talents led him to Broadway and to touring the country as the comedy star in numerous traveling productions. Edward Hume is shown here in one of his many comedy roles.

In typical theatrical fashion, Edward Hume met Frances Cossar, a young singer from Chicago, while they were on the road with a show, and they were married between a matinee and evening performance. She is pictured here in a production of *Sis Hopkins* that toured the country in the early 1900s.

Their daughter, Clare, born in 1914, made her stage debut in her father's act at the Majestic Theatre at the age of five and periodically performed with them, although she remained at school in Chicago with her grandparents when her parents were on tour. Young Clare is pictured here around the time of her stage debut.

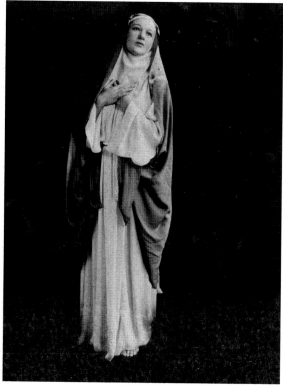

As a young actress, she became active in the Chicago Group Theatre and the new field of broadcast drama and both wrote and performed scripts for the Dearborn Radio Players. Josef Meier and Clare Hume were married in 1936, after which Clare began to play the leading woman's role of Mary the Mother in the Passion Play, which she continued to do until her retirement in 1991. This is a picture of Clare Meier in her early years as Mary the Mother.

Josef and Clare Meier were a theatrical couple of formidable talents, which they combined in the Passion Play. He was producer, director, and star of the Black Hills Passion Play, and she was his costar, wardrobe designer, and companion for over 60 years. This is a typical publicity portrait shot of them probably taken during the 1950s.

Josef Meier was a man of many talents and was a gifted writer and artist as well as a rugged outdoorsman. He enjoyed hunting and riding in the Black Hills and loved to entertain—from small gatherings of friends to the entire cast and crew. Company picnics were legendary, and there was always a group of "homeless" actors at the table for Thanksgiving and Christmas. This is a picture of Meier in his role as chef/host for one of the many company picnics in Spearfish.

Clare Meier, also a talented writer, was less gregarious but contributed to the well-being of her community through her participation in the creation of the first Spearfish library and numerous charitable activities and scholarships provided to young students both here and abroad. The Meiers were always active in their churches in Florida as well as South Dakota. Both were ardent music lovers, and the Meier household was filled with the sounds of the great classical composers. Josef is pictured at the organ (Black Hills Studios), and Johanna Meier was photographed later at the piano, with her parents.

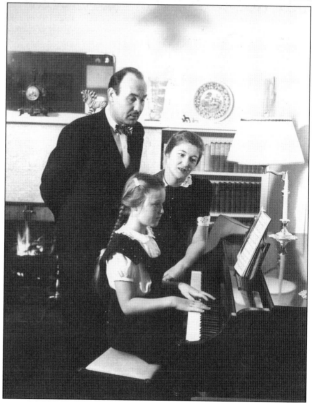

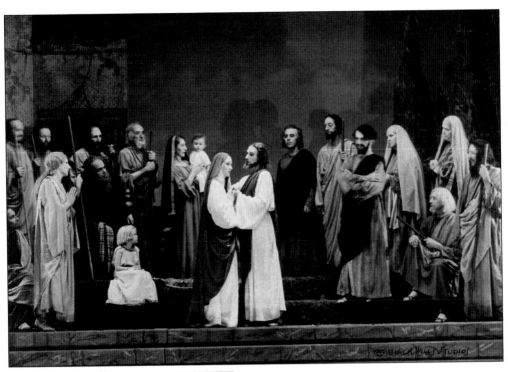

By the time the play had become settled in Spearfish, the author had been born into the family. Johanna remained the only child. The author is pictured here as an infant in the Bethany scene on tour and on her own first postcard.

Johanna Meier,
youngest member of the
BLACK HILLS PASSION PLAY COMPANY.

BLACK HILLS STUDIOS, INC.

Honors and awards were many throughout the years, recognizing the Black Hills Passion Play as an entity and Josef Meier's accomplishments as an individual. The play was recognized by three popes, Pope Pius XII, Pope Paul, and Pope John Paul. This is an image of the award bestowed by Pope John Paul.

The Black Hills Passion Play was awarded the National Freedoms Foundation Medal in 1953. Meier also received the Lifetime Achievement Award from the Institute of Outdoor Drama; an Americanism Award from the National Society, Daughters of the American Revolution; and the Bundesverdienstkreuz, Germany's highest civilian honor, for his part in bringing German culture to the United States, as well as his assistance in rebuilding the church in his hometown following World War II. This image displays a Papal Medal, the Americanism Award, and the German citation.

The AMERICAN LEGION CERTIFICATE
of DISTINGUISHED ACHIEVEMENT

This Certificate of Distinguished Achievement is Awarded JOSEF MEIER in recognition of his Outstanding Effort in presenting to the Peoples of America and the World the principles and ideals of Freedom and Democracy.

In further recognition of the contribution he has made since becoming a citizen of the United States in 1938, in presenting to free men in every land the Ideals of Christianity and Freedom from Hatred and Fear.

This award is made by Dubuque Post No.6 of the American Legion Department of Iowa.

Signed *Geo. E. Traut*, Commander.
Henry A. Bitter, Chairman Americanism Committee

Josef Meier received press awards, tourism awards, and the South Dakota Governor's Award for Lifetime Achievement in the Arts, as well as induction into the South Dakota Hall of Fame and a commendation from the American Legion, shown here.

Recognized as one of the four founders of South Dakota tourism, together with Custer State Park architect Peter Norbeck, Wall Drug's Ted Husted, and the Reptile Garden's Earl Brockelsby, Meier was one of the founders of the Black Hills and Badlands Association, receiving the Ben Black Elk Award, shown above, for his contributions to the development of state tourism.

In recent years, this new music building at Black Hills State University in Spearfish was named Clare and Josef Meier Hall in their honor. It houses the state-of-the-art Meier Recital Hall. The Meiers were esteemed publicly and were also admired within their extended family, for the countless care packages sent to Germany during the war and for helping young family members to begin careers and establish businesses in the difficult postwar years. (Black Hills State University.)

Life was at its most lively during the summers in Spearfish, when the Meiers joined in as many outdoor activities as time permitted between performances. Shown here are Clare and Josef Meier after a game of tennis.

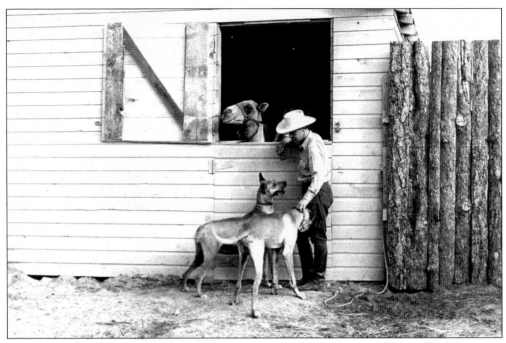

Animal care and affection played an important part in family life. There were always numerous dogs, big and little, in the household: Great Danes, dachshunds, German shepherds, Weimaraners, Dobermans, poodles, and even a shih tzu, as well as several mutts who joined the family through the years. Pictured above is an early shot of Josef Meier with Fanny, the camel, and Major and Dona, two of the great danes. At left, he is seen in later years with one of several pairs of dobermans, named Karl and Sheba.

Horses were always a part of the picture, as both the author and her father were dedicated riders; Johanna received her first horse, a shetland pony, when she was two years old. The author's equestrian training began on the back of one of the young donkeys and continued during family trail rides. The Meier family kept up the tradition, riding together for many years.

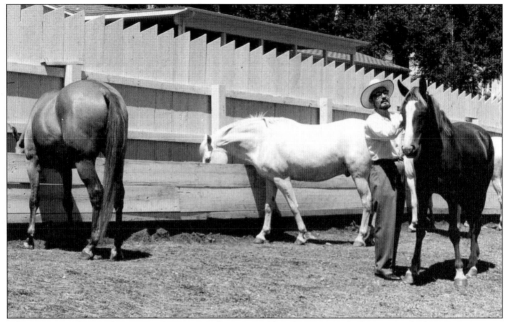

The picture above shows Josef Meier with some of his horses, and the image below is a picture of Meier with Senator Harlan Bushfield and "Potato Creek Johnny," one of the early Black Hills prospectors, who came down from the hills for a yearly visit. He was renowned for having discovered the largest gold nugget ever found in the area. (Black Hills Passion Play archives.)

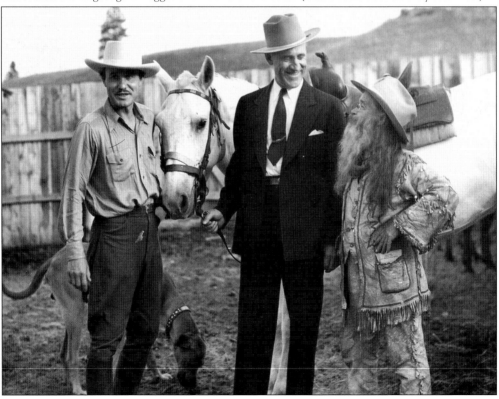

The Meier Ranch outside Spearfish featured largely in the scheme of things. Although the Meiers maintained their residence in town close to the Passion Play grounds, the ranch was and remains a working cow and calf operation. The Meier family cuts their own hay and harvests their own oats to feed the livestock. Josef Meier received a state conservation award for early development of irrigation in the area and played an active role in running the ranch. He made a great sacrifice when he allowed the ranch to be divided in half in order to assure that Interstate 90 ran through Spearfish, providing the town with three exits. Josef Meier is pictured with his prize Hereford bull, Dan Domino.

The author continued to perform in the play throughout her childhood and took on the dancing role of Salome in the King Herod scene at the age of 12. Gradually Johanna played some of the smaller women's parts as well. A family portrait captures the three Meiers backstage in the 1940s. An interview from Manhattan, Kansas, gives insight into the plans for the future, which were ultimately fulfilled.

Meiers Raise Daughter For Part Of Mother Mary In Passion Play

One of the youngest actresses ever to appear on a Manhattan stage is little Johanna Meier, right, who has a role in the famed Luenen Passion play of the Black Hills, which will have its Manhattan premiere next Monday at the high school auditorium.

Johanna, who recently celebrated her second birthday, has been in the noted production since she was five weeks old. She is the daughter of Josef Meier, who portrays the part of the Christus, and Clare Hume Meier, who plays the part of Mary, the Mother. Little Johanna will grow up just as her father in the environment of the Pansion play and will one day take over the part of Mary now played by her beautiful mother.

Little Johanna appears as one of the children which the Christus blesses when he makes his entrance into the city of Jerusalem. Like her distinguished father she is a veteran in the production at the age of two. Josef Meier made his debut in the Luenen play at the age of 10 weeks. He is now 35.

Four evening performances are scheduled at the high school, and matinee presentations will be given as follows:

Tuesday, Manhattan and Sacred Heart academy elementary school pupils; Wednesday, 2 o'clock, Manhattan junior and senior high schools and Sacred Heart high school; Thursday, 2 o'clock, rural pupils of both elementary and high schools. Each day Tuesday through Thursday reservations will be set aside for 200 college students, who are instructed to purchase their tickets in advance.

Reserved seat tickets are on sale at the Chamber of Commerce office.

Approximately 100 members of the Pearce-Keller American Legion Post and auxiliary and representatives of local churches attended a dinner Monday night at the community house and heard civic leaders discuss the Passion play. The Legion is the sponsoring organization here. Msgr. A. J. Luckey discussed the religious aspect of the famed play. Superintendent W. E. Sheffer the educational effect of its presentation, and Mayor J. David Arnold the benefits the performance will bring to the community.

108

At the age of 12, the author began dancing the nonspeaking part of Salome in the King Herod scene. (Black Hills Passion Play archives.)

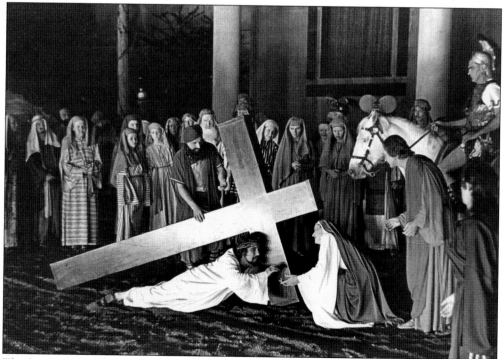

The family was joined by Josef Meier's nephew, Henry Meier, who had left his home in Germany to come and live with the Meiers in America. In this photograph, he is seen playing Selpha, the temple guard captain, standing behind the cross, being carried by the Christus. At extreme right is Henry's wife, Shirley Meier, who played the role of Mary Magdalene at that time. (Gilman, Lake Wales, Florida.)

The author spent her early years on the road with the Black Hills Passion Play and then in Spearfish, attending school there. By this time, Clare Meier's parents had retired from show business and moved from Chicago to Spearfish to care for Johanna while Clare and Josef Meier toured. When the wintering Florida season was established, things changed. Johanna traveled between Spearfish and Lake Wales and graduated from high school in Florida. Johanna had begun to play Mary Magdalene and eventually understudied her mother's role—Mary the Mother. The Meier family is pictured here together in the dressing room. (Black Hills Passion Play archives.)

A new path opened for the author, whose singing voice had previously gone unnoticed. As a graduating student, Johanna was entered in the Pan American Music Festival in Miami by the high school chorus director. Johanna won the vocal division and received a full scholarship to the University of Miami School of Music. Within a year, the author made her debut with the Miami Opera in a small role. This picture was taken following Johanna's first public recital. (Charles Ice.)

110

When it became evident that the author needed to pursue vocal training at a more advanced level, she entered the Manhattan School of Music in New York. Upon graduation, Johanna began singing with regional companies and ultimately joined the New York City Opera. In a career of nearly 37 years, she sang leading roles with the major international opera companies, the Metropolitan Opera, and symphony orchestras of the world. The author's parents came to hear performances when they could get away from their own performance schedule. During this time, the author met and married Guido Della Vecchia, a tenor of Italian parentage. The couple continued to sing together through the years. Johanna and Guido stand in front of the New York State Theatre at Lincoln Center.

Johanna and Guido Della Vecchia

The author's husband was welcomed into the family business; he worked in the box office, acquired his own horse, and eventually played Pontius Pilate. The Black Hills Passion Play family was now five, although cousin Henry Meier eventually left to establish a career as a professor of German. Clare and Josef Meier and Johanna and her husband, Guido Della Vecchia, are shown in costume. (Black Hills Passion Play archives.)

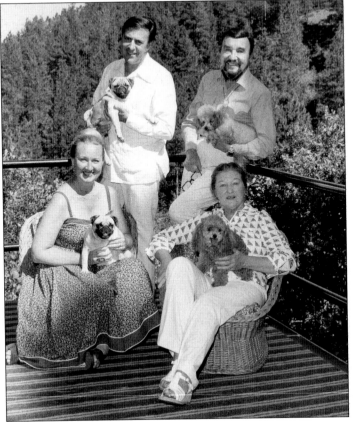

Now an international singer, the author's connection with the Black Hills Passion Play remained unbroken, and she and her husband visited Spearfish and Lake Wales frequently. These two photographs were taken for Christmas cards during the 1960s. As always, Black Hills Passion Play and family animals were an important part of the established Meier tradition.

As the seasons progressed, author Johanna Meier became more and more occupied with her career in opera and was traveling internationally over nine months of the year. Meier's engagement with the Metropolitan Opera in New York allowed her to establish a home there, but she was away singing much of the time. Always in the back of her mind was the plan to return to Spearfish to relieve her parents of production responsibility for the Black Hills Passion Play. As Meier's parents grew older, it was increasingly pressing, and in 1984, Johanna and her husband, Guido Della Vecchia, moved to the ranch in Spearfish. Johanna continued to travel and sing, but she and her husband worked to prepare their lives for the final chapter. These publicity pictures show Josef and Clare Meier during their performing years. (Black Hills Passion Play archives.)

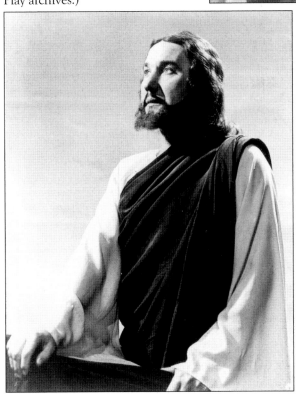

In 1991, both Clare and Josef Meier retired, he having played over 9,000 performances as the Christus, and she appearing nearly 7,000 times as Mary the Mother. In 1999, he passed away at the age of 94, and she died in 2007, on the opening night of the 68th season of the Black Hills Passion Play. Pictured are Clare and Josef Meier, Johanna Meier, and Guido Della Vecchia ascending the stairs in the Spearfish Amphitheatre.

Seven

THE NEXT GENERATION

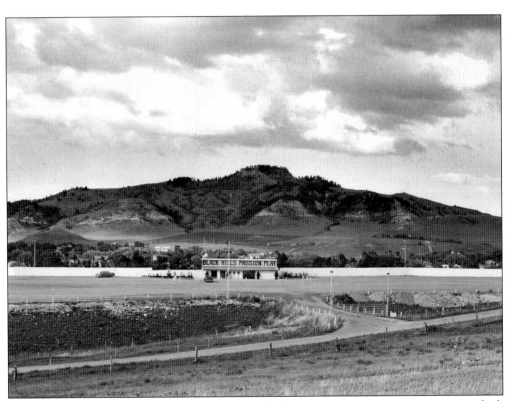

As the 76th season of the Black Hills Passion Play begins in America, it is important to look back through the years of achievement. For any play to have run continually for 76 years is an incredible achievement and even more so when one realizes the scope of coverage of the audiences. The Black Hills Passion Play has been seen in every major city in America, every state, and in six Canadian provinces. Millions have witnessed this theatrical phenomenon. Pictured is the Spearfish Amphitheatre in the 1960s.

DEDICATED TO

JOSEF MEIER

FOR HIS MORAL AND SPIRITUAL

CONTRIBUTION TO A BETTER AMERICA

MEMORIAL POST NO.71 AUXILIARY UNIT NO.71

AMERICAN LEGION LAKE WALES, FLORIDA

APRIL 21, 1963

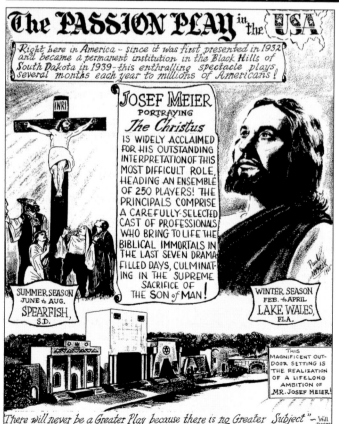

The above image is taken from a plaque at the base of the American flag that was erected at the entrance to the Lake Wales Amphitheatre in 1963. At left is a poster that carried a saying by Will Rogers, "There will never be a greater play because there is no greater subject." (Above, Gilman, Lake Wales, Florida.)

116

THESE QUOTES ARE TAKEN FROM CUSTOMER LETTERS RECEIVED THROUGH THE YEARS BY THE BLACK HILLS PASSION PLAY

"I have been coming to the Passion Play since I was child, 7 years old. You have managed to bless my heart every year." Mrs. M.C., Tampa, FL

"Please pass on to your management and staff our appreciation for the very meaningful performance; we heard many comments from the leaders on this wonderful presentation." S.B., Lt. Col, The Salvation Army

"The Passion Play gave me the comfort and peace I needed at the time of my daughter's death....I was not the only mother to have lost a child." Mrs. R.K., Haines City, FL

" Everything is so real, so alive. It all made you feel like you were there." Ms. D.F., Grand Rapids, MI

"Very uplifting at the end. It's what being a Christian is all about." Mr. J.M., Sudbury, Ont., Canada

"It made me happy that so many children could see and learn from the Passion Play. My little Sunday School girls saw it, and their new understanding, their wonder and awe almost overwhelmed me." Mrs. R.T., Duluth, MN

" There is something inside me which was not there before, an indescribable ' something' that is a sort of feeling one only gets from being so deeply impressed that one cannot forget for a moment in one's mind, what one has seen." Ms J.D., Seattle, WA

"Never before have I wanted so much to be able to give expression to that inner feeling of deep and growing gratitude to you and your splendid company of artists for the beautiful and studied performances you have given us." Mrs. D.H., Des Moines, IA

"You and your associates can have the satisfaction of knowing that you have added substantially to the cultural and spiritual life of the city during this season." Pres. J.N., Fenn College, Cleveland, OH

"Last night I realized a desire of mine since a child of 16.....to see and hear your Passion Play. This week will be a memory I want to keep for life." Ms. E.J., Calgary, Alb. Canada

"You and your cast took us back over the centuries to the time of Christ, so that we actually relived and experienced with Christ His Passion and death. Be assured of this, we are better boys and girls for having witnessed such a magnificent spectacle." D.B., Saint Martin School, Buffalo, NY

"I had no real conception of just what would take place that cool night under the stars. As the life of Christ unfolded from the pages of the Bible I didn't 'see' the Passion Play; I became a part of it myself, caught up in the realness of the sets, the beauty and reverence around me everywhere, and seeing what we have always seen without hearing.......the words of Christ and all those having an effect on His life. I think that your outdoor cathedral is about the only place where Christians of all denominations or walks or life stand together in one common faith, as one complete family." Ms.M.S., Wausau, WI

The influence of the Black Hills Passion Play has been far-reaching, as the many letters and testimonials attest. Here are some samples of the correspondence received from audiences through the years.

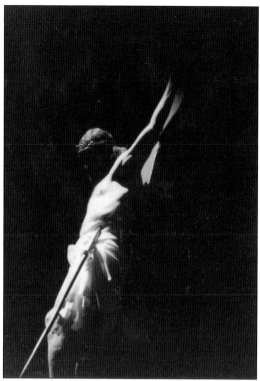

The play has provided a message of spiritual inspiration through the years, but it can be enjoyed on many levels. This historic example of theatrical development still resonates with audiences today. This is not a *Jesus Christ, Superstar* performance, full of smoke and mirrors and special effects. It is a traditional drama that has come down through the ages, with a classical text, which first drew the populace in the Middle Ages. Josef Meier is shown as the Christus during a performance of "the piercing of the side" of Jesus on the cross.

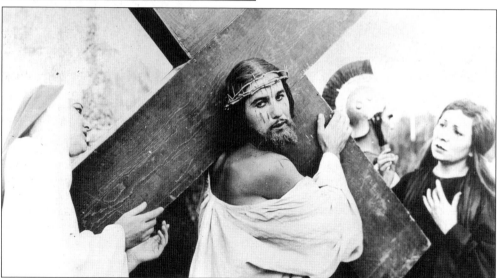

The play's power was evidenced in 1937 in Sioux Falls. There the Meiers met the state penitentiary chaplain, who wanted the inmates of the penitentiary to see the play. A performance was arranged, with cells for dressing rooms and trustees as stagehands. The prisoners were transfixed. According to the warden, "I could have opened every door in the establishment and no one would have left." The prisoners were especially moved by the scene pictured, in which Jesus encounters his mother while carrying the cross to his crucifixion—it called to mind the anguish of their own mothers dealing with the tragedy in their sons' lives. Josef Meier plays the Christus; Clare Meier plays Mary the Mother; and Rosa Germain plays Mary Magdalene.

Another highlight in Passion Play history came in 1993, when Pope John Paul came to Denver. Thousands of Catholic youth traveled to Colorado to be present at his mass and en route stopped over to see the Black Hills Passion Play. A full mass was held in the Spearfish Amphitheatre that afternoon, with the attendance of the archbishop of St. Paul and Minneapolis, 15 bishops, 38 parish priests, and over 8,000 young people. After the mass, the youth were bused off to various locations where they were to be housed and fed and then brought back for the performance that night. They overflowed the seating areas and gathered on the grass apron of the stage and the hillside; the cast was somewhat dubious as to what the attention span of so many young people would be, but they proved to be enthralled with the production from the beginning, applauding each scene, taking hundreds of photographs, and offering prolonged cheering at the end of the performance. (Rapid City Journal.)

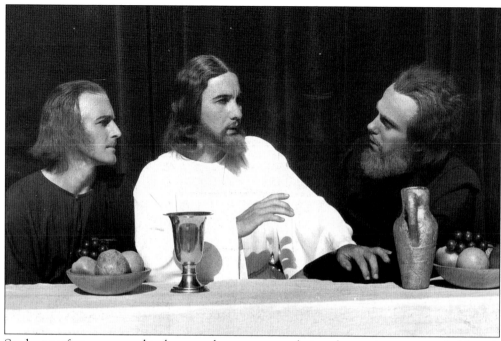

Student performances used to be a regular occurrence during the touring years, and although the theaters were still integrated, it was Passion Play policy that regular performances be given for the black schools and public as well as the white. Pictured is a scene from the Last Supper, with Josef Meier as the Christus. (Black Hills Passion Play archives.)

The play is viewed as a spectacular example of outdoor drama and is a major tourist attraction. The Black Hills Passion Play began drawing people to South Dakota while tourism was in its infancy and has been a guiding force in the area ever since. Appearing early in feature stories in the *Saturday Evening Post*, *Reader's Digest*, *Time*, *Life Magazine*, and other national publications, the production set the standard for outdoor drama. It is listed in the best seller *1,000 Places to See in the United States and Canada Before You Die*, shown here. (Workman Publishing Company.)

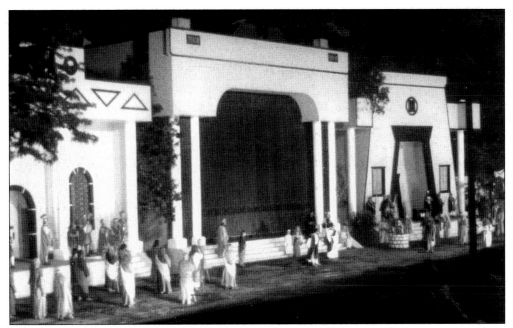

A large map in the Visitors Center lobby shows visitors from all the major European countries, as well as places as far afield as South Africa, Brazil, and Israel. Several years ago, the company was contacted by a Chinese tour group that wanted to see "the Jesus play," although none of them spoke English. A guest book is provided in the lobby, where visitors register names and points of origin. Center stage, pictured, rises some 40 feet at the proscenium.

Currently used costumes, wigs, and props are displayed for the backstage tour, which give the audience a better idea of the enormous detail involved in presenting the play. Historical lectures have also been offered on "The Time of Jesus and Jesus in Time," to help people understand the political as well as religious pressures that were present in the biblical era and his life as defined by his times. Shown here is a sketch of one of the wide variety of costumes used in the play, by M. Davis.

A backstage and museum tour has been offered since 1991, and many archival materials are on display. The tour takes visitors from early materials depicting the touring days and the construction of the Spearfish Amphitheatre to costumes and memorabilia of former actors. Josef Meier's theater trunk and Clare Meier's makeup case recall their lives onstage and off. The tour winds through the amphitheater and backstage, where visitors see set pieces up close, peek into dressing rooms, and encounter the animals firsthand.

As the author and her husband assumed responsibility for the production, they stepped into a variety of new roles. Johanna Meier assumed the directorship and the role of Mary the Mother. Guido Della Vecchia took over as general manager and plays the part of Judas. The legacy continues. (Black Hills Passion Play archives.)